POSTCARD HISTORY SERIES

Dennis

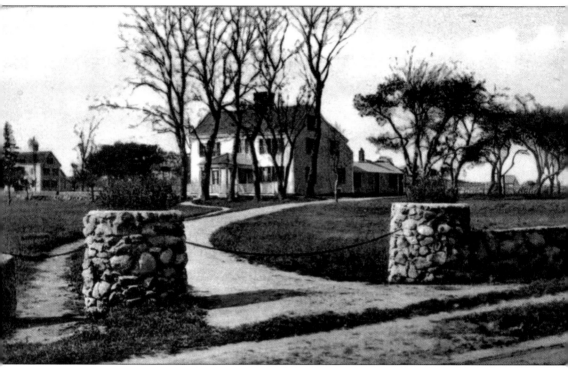

The town of Dennis was incorporated in 1793, after being spun off from the eastern portion of the neighboring town of Yarmouth. It was so named 30 years after the death of Josiah Dennis, who was a local reverend here for 36 years and who became a much-loved figure in town. His home, pictured here, was built in 1736 and is now known as the Manse. Purchased by the town in 1967 for use as a museum, the Josiah Dennis Manse now serves as a home showcasing the many artifacts of the Dennis Historical Society. This historic building is found at the intersection of Whig Street and Nobscusset Road in North Dennis. The postmark on this postcard is dated 1906.

On the front cover: Pictured here is Scargo Tower in North Dennis around 1939. (Courtesy of Helen Angell.)

On the back cover: Bass River Lighthouse on West Dennis Beach is seen here around 1907. (Courtesy of Helen Angell.)

POSTCARD HISTORY SERIES

Dennis

Scott I. Walker and Robin E. Walker

ARCADIA
PUBLISHING

Copyright © 2007 by Scott I. Walker and Robin E. Walker
ISBN 978-0-7385-4989-7

Published by Arcadia Publishing
Charleston SC, Chicago IL, Portsmouth NH, San Francisco CA

Printed in the United States of America

Library of Congress Catalog Card Number: 2006939086

For all general information contact Arcadia Publishing at:
Telephone 843-853-2070
Fax 843-853-0044
E-mail sales@arcadiapublishing.com
For customer service and orders:
Toll-Free 1-888-313-2665

Visit us on the Internet at www.arcadiapublishing.com

In loving memory of Alice Ruth Winter 1929–1995

CONTENTS

ACKNOWLEDGMENTS

We wish to thank the following members of the Cape Cod Postcard Collectors Club for generously making available to us their collections of postcards and other materials for use in this book and for providing their accompanying knowledge of the postcard subject matter: Helen Angell, Chip Bishop Jr., Jim Carr, and George and Grace Snow. Also we wish to thank Carole Bell, Robert and Virginia Briggs, Richard S. and Nancy Howes, and Sarah S. Kruger for the generous use of their personal collections, materials, and insightful knowledge. Many thanks are due to the following people who took time from their busy schedules to sit down with us and provide additional background information regarding the content of the postcard images: Nancy Crowell-Cotoia, Joshua L. Crowell, Burton N. Derick, Phyllis Robbins Horton, Al Howes, Brendan Joyce, and Nancy Thacher Reid. We would also like to thank the Dennis Historical Society for making their postcard collection available for use in the book and for offering their positive support of the project. We greatly appreciate the efforts of our editor, Erin Stone, for always being available for guidance. A final thank-you to the numerous individuals not specifically named who we approached and asked a single question or two in order to help us clarify significant facts where necessary relating to a postcard. As neither historians nor postcard collectors, our gratitude to others is significant.

INTRODUCTION

Postcards with pictures on them first began to be widely used in the United States soon after the passage of the Private Mailing Card Act in May 1898. It allowed private publishers for the first time to create and sell postcards, which had previously been issued only by the federal government in somewhat bland formats. In no time at all, the demand for picture postcards mushroomed, and a collecting craze began to spread throughout the country. It is said that the amount of postcards that were produced doubled every year between 1898 and 1912, and the pastime of collecting postcards became the greatest collectible hobby that the world had then ever known. U.S. post office records for the fiscal year ending June 30, 1908, indicates that 677,777,798 postcards were mailed that year, a figure representing an average of over seven and a half postcards mailed for every man, woman, child, and infant then living in America. Postcard collecting and use had become a public addiction. Photographers roamed the cities and towns across America seeking all varieties of subject matter that could then be made into postcards to meet the demand.

During this period most of the postcards were actually being printed in Europe, especially in Germany, where printing methods were the best in the world. Although the craze for postcards diminished by the time World War I began, postcards continued to be published and collected. The outbreak of war saw a quick decline of imported cards and brought the supply of postcards from Germany to an end. Many of the finest publishing houses in both England and Germany had been bombed, with original art and equipment having been destroyed.

After the war, the German publishing industry was never rebuilt, and cards began being supplied by printers in the United States. American technology started to advance and domestic companies began producing higher quality cards. Several local companies published or distributed postcards here in this area, among them being the H. A. Dickerman Company of Taunton, and the E. D. West Company of South Yarmouth.

The town of Dennis was also undergoing changes as the 1900s began. The invention of the locomotive train had irreversibly altered the industries and lifestyles of many local people in the villages here. The maritime trades suffered the most, as the descendants of many generations of seafaring families who had made their way as a result of these enterprises found their livelihoods sharply curtailed by the invention and widespread use of the train. Not everyone in Dennis made their living at sea, but a great many did. The residents here tried their hands at several new industries within town in the late 1800s, although very few were able to remain successful for very long.

Train travel also allowed residents to more easily locate elsewhere than ever before and many did so by leaving the area. As the 1900s began, the town of Dennis was facing a declining population,

and was a town devoid of a predominant industry. A great number of Dennis residents during and after this period were not well off financially, with many existing at a subsistence level of living. A few crops in the yard, a few fish from the sea, maybe a hog for slaughter. Red meat was a rarity. Steady employment was not plentiful.

Near the beginning of the 20th century, people first began to come to this area as a summer destination, and the one industry that began to take root was tourism, borne from the invention of the automobile. People were able to travel easily to new destinations, and Cape Cod proved to be a much sought after location. Initially these visitors were native sons and daughters who had moved away and were retuning on trips to see their family here. Then came a summer influx of schoolteachers and college instructors who stayed here over the summer during their time off from the school year. Other visitors and vacationers soon followed.

In response to the increase of seasonal visitors, many residents, particularly elderly widows, found that they could easily rent rooms within the spacious homes that had been built years earlier by their late sea-captain husbands. A great number of people were then able to support themselves for an entire year based on what they took in during the summer. Lodging houses and inns started to become more commonplace.

This collection of postcards from the late 1890s up through the 1960s provides a glimpse of what the town of Dennis looked like when the transformation to a tourism and vacation destination was occurring. The familiar subjects depicted within each village are not all inclusive, and are limited by whatever postcards may have been produced, and so availability somewhat dictates the subject matter. Some villages simply had more postcards made from within their communities than the others did, oftentimes based upon what communities drew more people, which the postcards could then be sold to. They are not presented chronologically, but are random views from within each of the five villages of Dennis.

In several of the early postcards you will see a small horse-drawn carriage in or along the roadway. This was the photographer's carriage that he traveled about in while snapping away with his camera. Many of the early landscape scenes show an area with few trees. Nearly all of Cape Cod was deforested by 1815 and remained that way up until the early 1900s, making some of these images intriguing to see without the foliage we are now more accustomed to in our surroundings.

This is not a complete historical work by any means, and it is not intended to be. There is a wonderful, extensive history book that has been written about the town of Dennis, and if you have not read through it, then we hope that perhaps what you find here may lead you to do so, or might inspire you to make a visit to see the Dennis Historical Society holdings or attend their sponsored programs and learn a bit more about Dennis history.

One

NORTH DENNIS

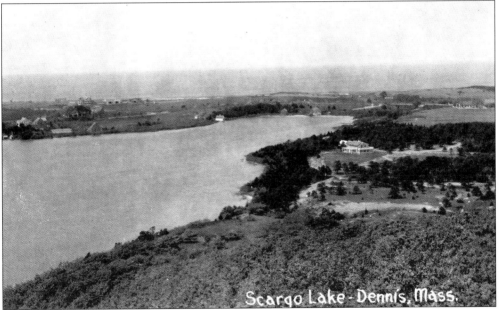

Scargo Lake - Dennis, Mass.

The first European settlers appeared here in the late 1630s, when the area went by the name Nobscusset, an eastern section of what was then still part of the town of Yarmouth. In the early 1800s, shortly after town incorporation, it had begun to be called North Dennis, which continued in general use through the mid-1900s. Although this village goes by Dennis now, several locals still refer to it as North Dennis.

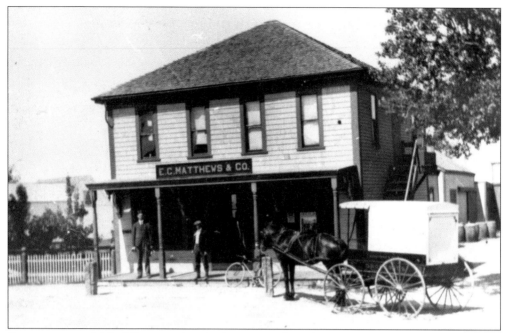

For many years this building, standing in the center of North Dennis at 776 Main Street, housed the post office and a general store. It was long a place where locals would meet and exchange current news and events. The building today still looks much unchanged from the days gone by, ever since it was moved to this spot in 1886. Today it is home to Leslie Curtis Antiques.

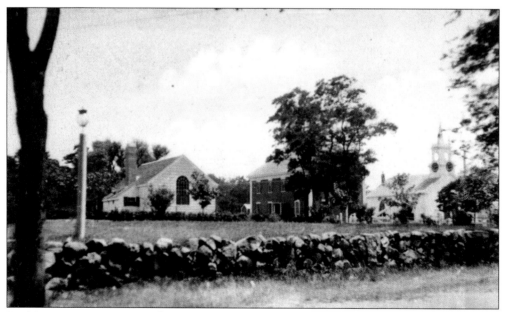

Looking across Main Street from the North Dennis Post Office building, mentioned above, in the years from 1925 to 1955, one could see (left to right) the Dennis Memorial Library, the North Dennis Schoolhouse, and Dennis Union Church.

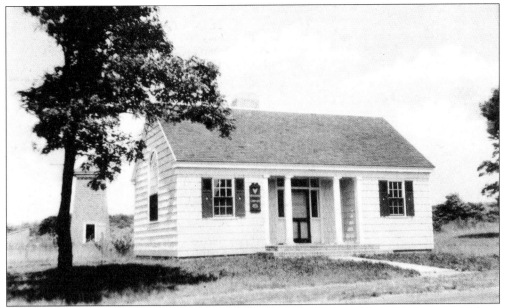

The Dennis Memorial Library was built in 1924 as a memorial to the 94 men and women from Dennis who served their county during World War I. Two wings were added to each end of the building in 1957, and another larger room added in 1968. An extensive expansion to the library was completed in July 2005.

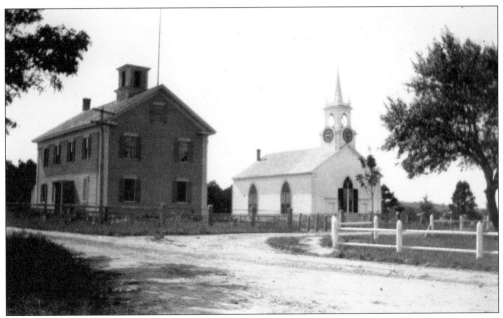

The North Dennis Schoolhouse (left) once fronted Old Bass River Road and later served as a firehouse. Five centralized schoolhouses, like this, were built within the town before 1870 to replace more than a dozen one-room schoolhouses throughout town, which were deemed outdated. The fire station still exists at the same site, although within a much newer structure that was built after the building seen here was demolished in 1956.

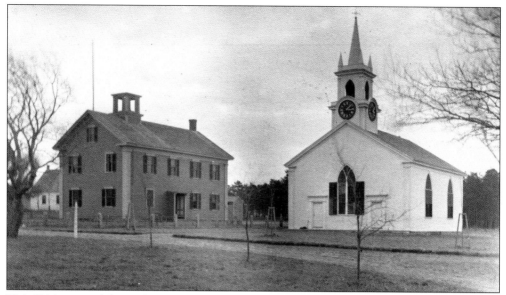

This 1906 postcard shows the Dennis Union Church (right), which was originally constructed in 1838. Rather than each running their own separate meetinghouses, the different local religious groups, here comprised of Methodists, Unitarians, and Congregationalists, agreed to join together in worship at one location, in union, thus the name given for the church.

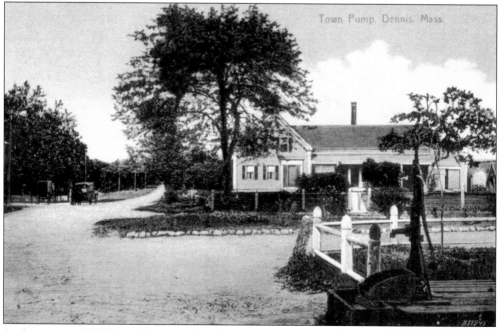

At the corner of Old Bass River Road (right) and Main Street (left) is the town pump, which in every village served as a source of public water from the community well. Its original location was further back off the main road, approximately where the bandstand gazebo is now located. The pump has been in the care of the Dennis Village Improvement Society since 1902.

The home of sea captain Moses Howes was built in 1854. He and his wife had four sons, born in North Dennis, all of whom also went to sea. Since the late 1960s the property has been used for commercial concerns due to its prime location at the northwest corner of Main Street and Hope Lane.

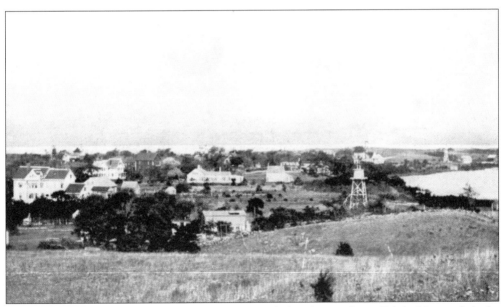

A spacious home was built on Main Street in 1899 belonging to Capt. Calvin Howes. It is the large white house on the left in this wonderful panoramic view from the village end of Scargo Lake, showing the lake on the right and the Cape Cod Bay in the distance. The home has for many years been known as Scargo Manor.

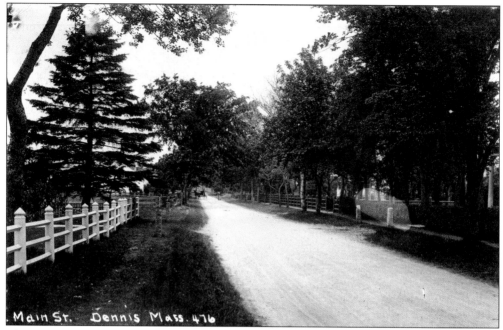

This picture was taken while looking west on Main Street just before the town landing. Elm trees like those pictured were once quite common in many of the Dennis villages. Dutch elm disease had taken firm hold of these large trees by the 1970s however, and most all of the diseased trees were then removed from the sides of the roadways. Very few are seen today.

Here is the same section of the roadway found in the previous postcard, but from the west end looking east. Since it was east of the town center, it was previously referred to as East Main Street. Scargo Manor is the large home on the right. This card is postmarked 1912.

14

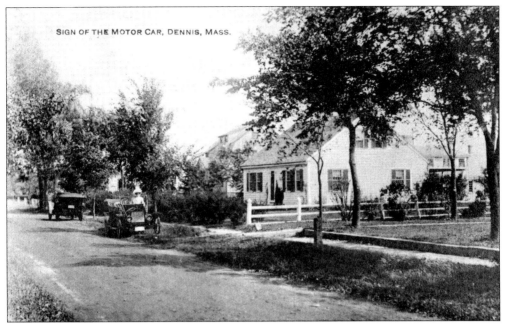

SIGN OF THE MOTOR CAR, DENNIS, MASS.

One of the first businesses to appear specifically addressing the influx of visiting motorists was the aptly named Sign of the Motorcar in 1910. This inn and restaurant was on the south side of Main Street, immediately left of Scargo Manor. It operated for many years through the 1920s. The building was moved to Chatham many years ago after the business was no longer.

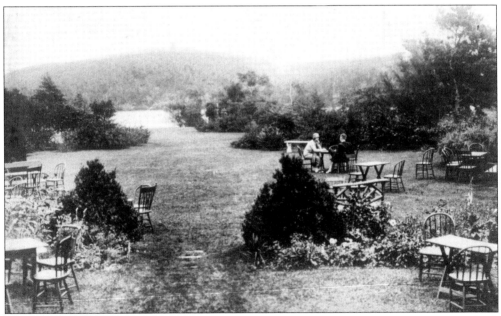

The grounds at the highly successful Sign of the Motorcar included a serene setting in back with tables and chairs outdoors for tea and conversation. A gentle sloping lawn led to the shore of Scargo Lake for bathing or a row in a boat. There was also said to be an outdoor dance floor near the water's edge, among other amenities.

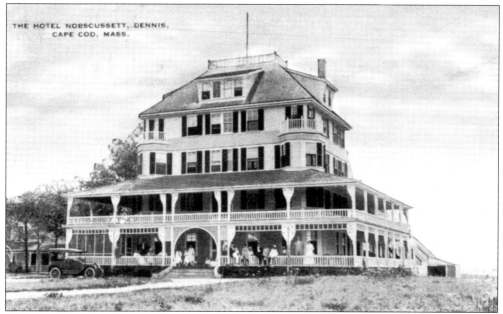

THE HOTEL NOBSCUSSETT, DENNIS,
CAPE COD, MASS.

Sitting high on the bluff overlooking Cape Cod Bay stood the grand Nobscusset Hotel, built in 1872. Owned by the Tobey family, it was one of the most luxurious resorts on Cape Cod, and the center of summer activities for many North Dennis visitors. The facility boasted several rental cottages, a golf course, tennis courts, a billiard room, a bowling alley, and a dance hall.

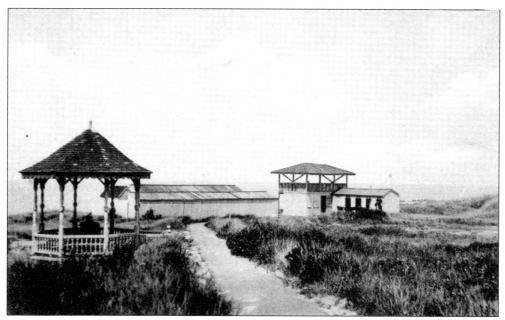

Along the bluff near the water's edge at Nobscusset Hotel stood a large bath house pavilion, including a covered balcony on the top of the smaller building to take in the sea views. There was also a pier for guest use that extended out several hundred feet into the bay.

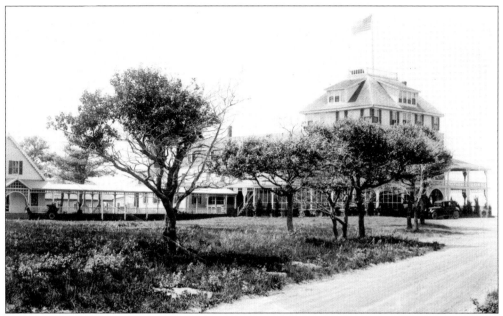

The Nobscusset Hotel operated up until 1929, when it suffered the financial fate of the Great Depression. It was dismantled in the early 1930s, and as was common in that day, most all materials were saved and reused. Several houses on and about Scarsdale Road were constructed by builder I. Grafton Howes with timbers and materials salvaged from this hotel.

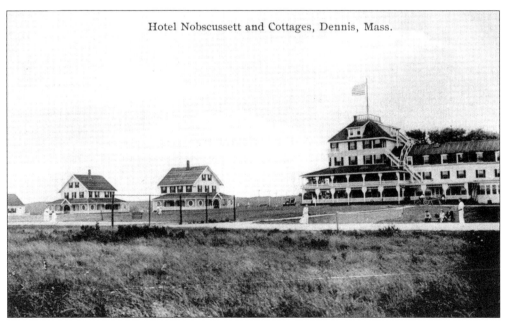

Although the grand hotel is no longer, the two "cottages" on the left in this photograph are now private residences and are tucked away on the Luscombe Lane side street in the same spot and positions shown in this 1920s postcard.

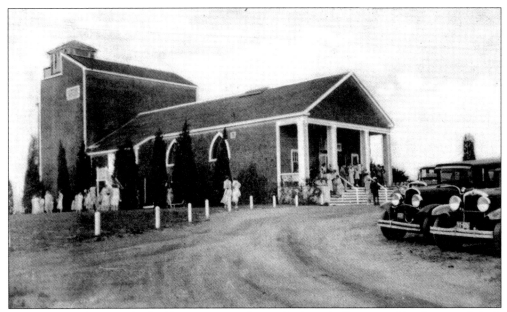

The Cape Playhouse—the "Oldest Summer Theater in America"—opened its doors on July 4, 1927, and through them have passed some of the most famous actors and actresses who have appeared in many fine plays here in the decades since. The founder, Raymond W. Moore, had originally planned to name the enterprise the Little Theater of Cape Cod.

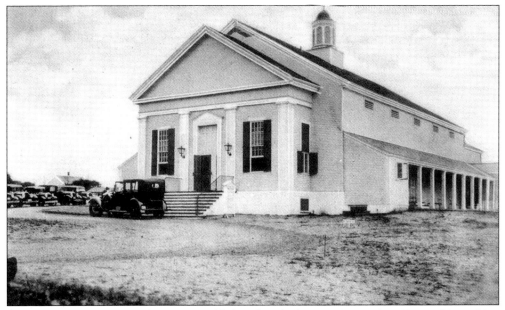

The Cape Cinema movie theater was added to the playhouse property in 1930, and its ceiling is home to the largest single indoor canvas painting in the world, measuring 6,400 square feet. The cinema was a host in 1939 for the world wide premier of a movie one may be familiar with, which was titled *The Wizard of Oz*.

The auditorium of the playhouse was originally an old local Unitarian church building. It served several other owners and useful purposes over many years before ending up sitting idle as a barn out in back at a local homestead along Main Street. Moore purchased it for a few hundred dollars, and local labor disassembled it, moved it, and rebuilt it on the playhouse property.

At one point through the 1930s, there were full-time gardeners on the payroll of the Cape Playhouse in order to maintain the vibrant floral gardens that once adorned the property, which indeed became the home of Moore's vision of a complete center for the theater arts.

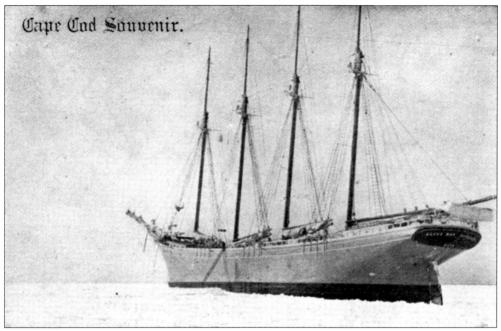

Cape Cod Souvenir.

The schooner *Alice May Davenport* paid a brief surprise visit here when she ran aground off Nobscusset Beach during a gale in January 1905. Curious North Dennis onlookers trekked to the beach to have a look at the 195-foot cargo ship sitting on the sandbar. At the right tide, the 1,100-gross-ton ship was successfully floated free from her temporary berth two months later. She was a new four-masted schooner, which had recently been built in Bath, Maine. She continued enduring a somewhat dubious history, having later run aground off Long Island in 1918, and still later she was involved in a collision at sea with a Coast Guard cutter in 1921.

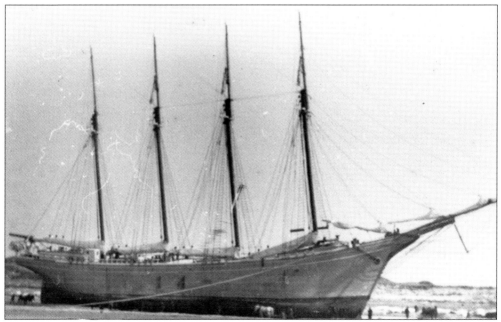

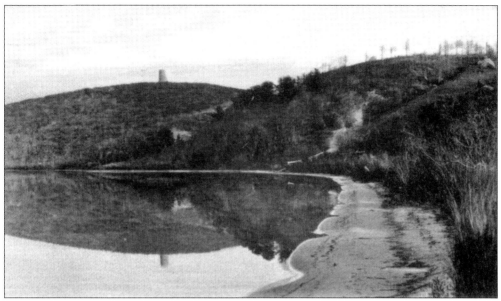

There are many folklore stories about the creation of the fish-shaped Scargo Lake, most of which involve old Native American legends. Some of these stories describe the work of mythical giants, or of the lake being dug by hand with scallop shells by local tribesmen, with the residue having been set aside in a large heap which became Scargo Hill.

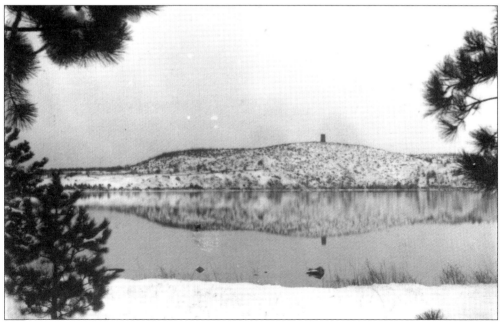

During the winter months through the 1940s, there was a thriving ice-harvesting business based at the northeast end of Scargo Lake. Blocks of ice were cut from the frozen lake surface and stored in a large two-story icehouse. Packed with sawdust and hay for insulation, the product would last through the summer months. Ice could then be trucked to residents year-round for their refrigeration needs.

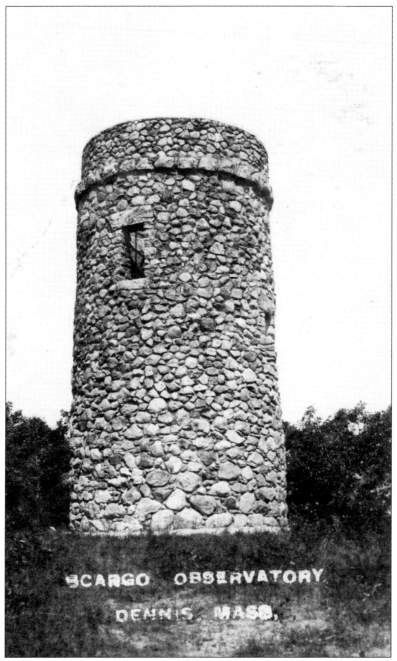

Scargo Tower sits atop the highest point in Dennis. It was originally know as Scargo Observatory, and at one time it actually housed a telescope. Being privately owned, it was first built of wood in 1874 as a tourist attraction for the use of the guests staying at the Nobscusset Hotel. A strong gale eventually blew it to the ground, and it was destroyed. The wooden tower was then reconstructed by its owners with guide wires in place to prevent another such occurrence. Unfortunately this maneuver did nothing to prevent a fire that swept over the hillside and destroyed the tower yet a second time in the late 1890s. A stone mason by the name of John Murphy was then hired in 1901 to construct the tower of stone that is known today.

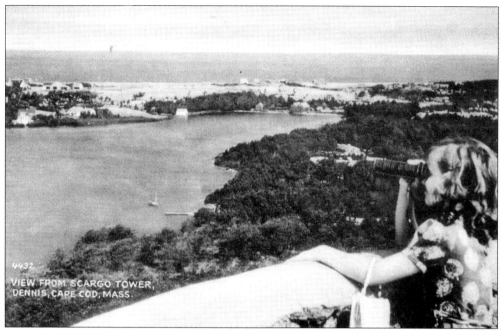

VIEW FROM SCARGO TOWER, DENNIS, CAPE COD, MASS.

Some other examples of Murphy's stonework can still be seen in North Dennis: the stonewall along Seaside Avenue fronting the Bleakhouse Downs development and a retaining wall running along the street at the front edge of a residential property on Main Street, which is located diagonally across from the entrance to the Cape Playhouse.

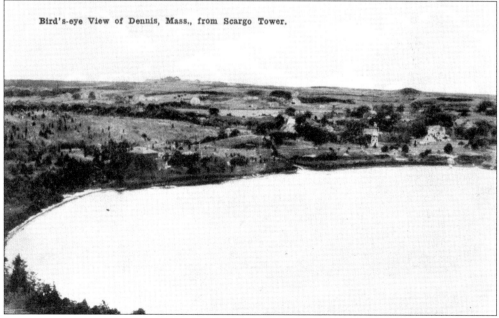

Bird's-eye View of Dennis, Mass., from Scargo Tower.

In 1929, the Tobey family, which had for many years owned Scargo Tower and the land surrounding it, donated the tower and land to the town. Many a visitor and resident alike have climbed the spiral stairway to take in the view from the top of Scargo Tower, with its sweeping vista of Scargo Lake and Cape Cod Bay beyond from Plymouth to Provincetown.

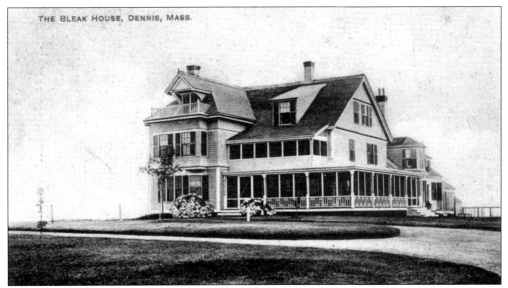

The Bleakhouse was a large home with 25 acres on Seaside Avenue. Dating to 1805 and owned by Howes family descendants, it came into possession and use by the Coast Guard during World War II for detection of German military activity in the waters of Cape Cod Bay. Young guardsmen lived here and patrolled the local beaches with guard dogs, which were housed and trained at the property. That activity, along with the inexperienced lifestyles of the guardsmen, caused extensive disrepair to the home. It was torn down before Bleakhouse Downs was developed in the early 1960s.

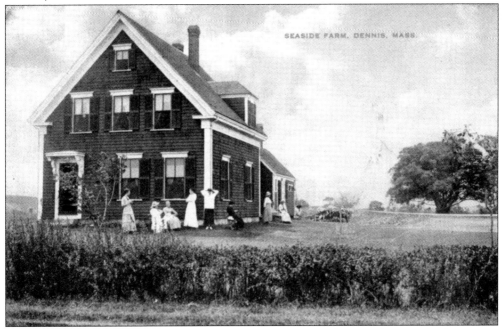

Further down on Seaside Avenue was the property known as the Seaside Farm, built in 1890, which was also owned by other Howes family descendants. A large wrap-around stone porch was subsequently added onto the home, which gives the property its more familiar appearance today at 77 Seaside Avenue.

The Willows Inn was located on the same property as the Seaside Farm and was another early lodging house for the summer visitors. It had a very long run in the hospitality business for several different owners. The Willows Inn building, originally built about 1812, was demolished in 2005 and replaced with a new structure.

CRANBERRY PICKING CAPE COD, MASS.

During the War of 1812, the seaports were blockaded by the British fleet, forcing local men to stay ashore. While home, Capt. Henry Hall of Dennis took note of the fact that sands had blown onto his cranberry bog, causing his berries to grow bigger and better. Thus the cultured cranberry sanding process came to be invented, quite by accident, for during idle hours Hall had removed a stand of trees that separated his cranberry yard from the windy beach bluff.

Cape Cod Souvenir.

Back in the 1800s there was a massive 600-foot pier in this location that facilitated the landing of packet ships to and from Boston. Today it is known as Corporation Beach, so named for a corporation that was formed by several residents who utilized the area for these business pursuits. In the background is Nobscusset bluff, a 60-foot coastal bluff that once existed here.

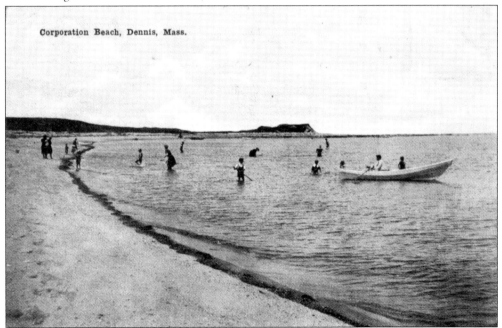

Corporation Beach, Dennis, Mass.

Within this bluff were large deposits of clay and stone, and a significant portion of it was trucked away and used as fill on Route 6A during the early 1900s when the local roads were undergoing improvements to meet the requirements of the coming automobiles. Most all of it was used, and the bluff was drastically reduced in size. Wind and sea took the rest of it, and the bluff was gone by the 1930s.

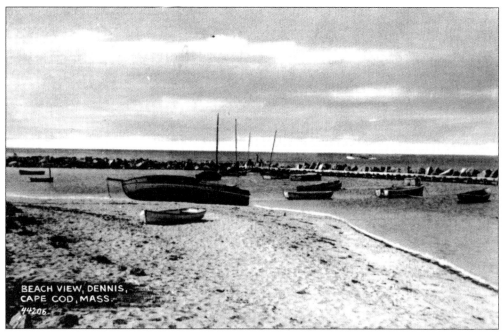

In the early to mid-1900s, Nobscusset Harbor, as it was known, operated as a safe haven for several small boats, a continuation of harbor activities that had occurred here for generations. The seawall in this photograph is quickly recognizable to those who have visited this popular north-side beach. A small harbor, such as this, sufficiently served the purposes of the few local bootleggers here during prohibition.

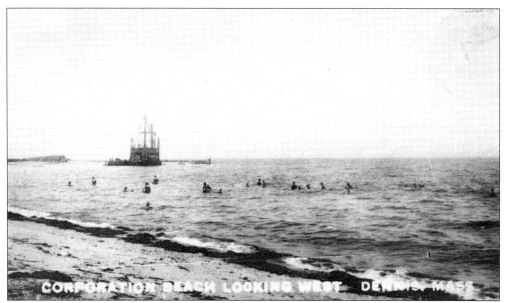

This vintage postcard shows a dredger at work in the 1920s clearing the channel of the Nobscusset Harbor, with some scattered bathers in the foreground. There was not yet a lower parking lot here at Corporation Beach as there is today.

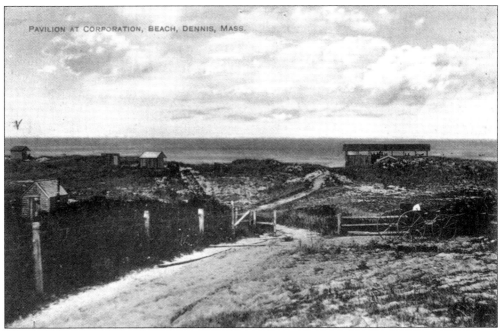

A bath house pavilion was built in the early 1900s at what is now known as Howes Street Beach by the Howes family, who operated the Willows Inn nearby. It was erected specifically for the enjoyment and use of guests staying at the Willows on land then owned by the Howes proprietors.

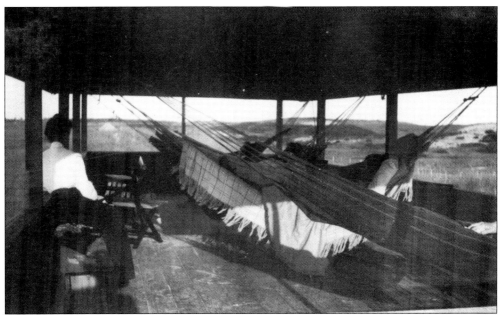

The pavilion on the bluff featured small rooms on the ground floor for changing in and out of bathing attire when at the beach. The second floor featured open walls with a roof overhead where hammocks hung for guests to have a rest and take in the sea view and sea breezes on a lazy summer afternoon.

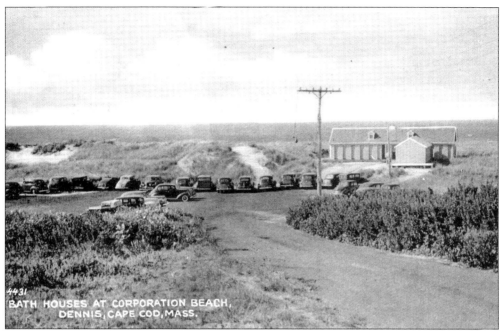

In 1939 the Town of Dennis purchased the Howes Street Beach area for public beach use and constructed a newer, larger bathhouse pictured here. Until it became known as Howes Street Beach, it was still considered part of Corporation Beach but frequently referred to as Bath House Beach. The bathhouse was eventually removed in the late 1950s.

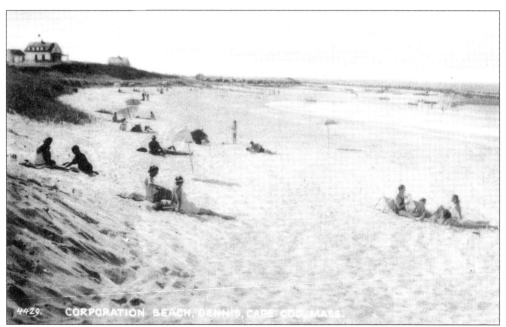

In the 1940s and 1950s, the beaches were a spacious, uncrowded place to spend the afternoon. In the background is the Nobscusset Harbor area and an older two-story "snack bar," formerly a private residence, that sat high above the beach in the same general location as the one there today.

This is a view looking down along Seaside Avenue in the early 1900s from what was known as Newcomb's Hill. The Bleakhouse, with its long driveway, is in the foreground and was the only home existing on that entire side of the road at the time. Furthest down Seaside Avenue at the end on the left side of the road is the Seaside Farm building and its barn with cupola.

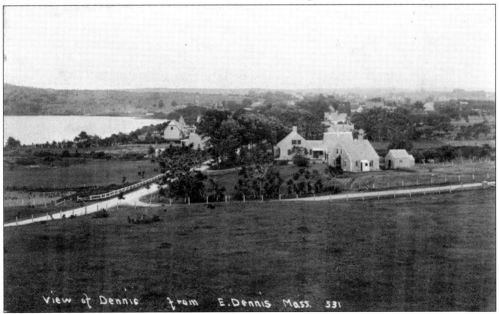

View of Dennis from E. Dennis Mass. 531

The photographer on Newcomb's Hill has now turned to his left a bit, showing the intersection of Seaside Avenue coming in from the right side and joining Main Street, which of course runs along Scargo Lake off west toward the center of town. These two pictures were likely taken one after another. (See page 125 where the photographer continues photographing to the south and to the east from this vantage point.)

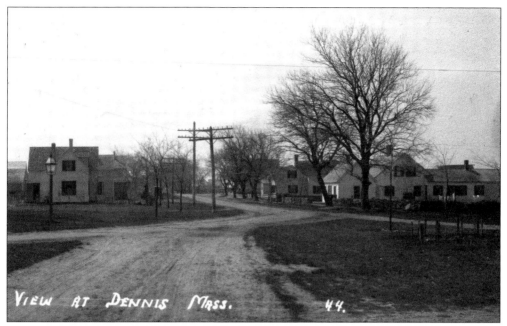

This 1918 view was taken at the intersection of what is now Nobscusset Road, New Boston Road, and Main Street. The direction is looking west on Main Street, where the Dennis Public Market property would have been on the immediate left (just out of view). The property that is first visible on the left in this postcard is where the clothing shop Linda Burke is now located, at 633 Main Street.

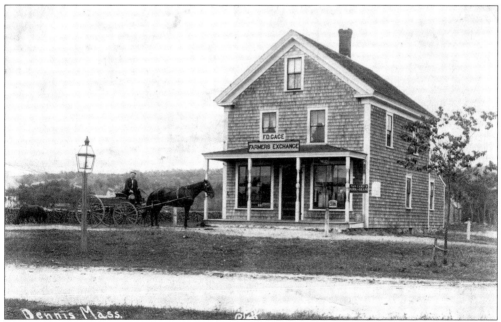

Here is the Main Street general store business of Fred Gage, which operated into the early 1930s. The Gage Farmers Exchange building is located at 601 Main Street and in recent years housed an antique shop and an art gallery. Van Kamp's Pork and Beans, Jell-O, and an unknown brand of tea are among the products advertised in the windows of the store in this 1911 postcard.

An original section of the Dennis Public Market building dates to more than 100 years ago, with subsequent sections having been added over time. There was originally an IGA market on this spot for several years before Louis Terpos began running it in 1940 under the name Dennis Public Market. Known to the locals as "Louie's" or "DPM," it is one of the longest running same-named businesses in this area.

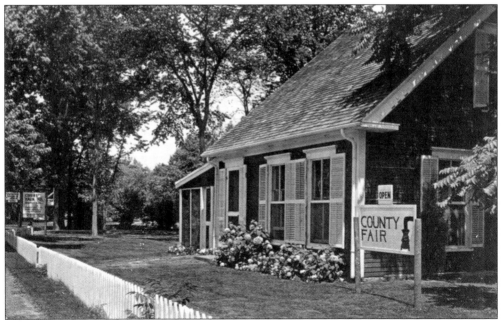

The County Fair restaurant and its successor, the Red Pheasant, have operated from the same Main Street location since the 1950s. The home in front was the former residence of Capt. Caleb Howes, and the dining room section is said to have come from the former Corporation Beach wharf area, having previously been a ships chandlery— a store offering supplies for both individual seamen and vessels.

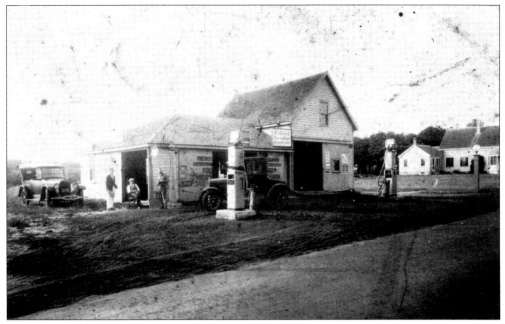

At the northeast intersection of Nobscusset Road and Route 6A stood this early-1920s gas station (above), which had previously been a blacksmith shop and was one of the few places locally for motorists to refuel. Years later the locally owned and operated Dennis Garage (below) was in business at this spot beginning in 1965 for a 20-year run, the proprietors having moved here from their previous business location immediately east of, and prior to the existence of, the Dennis Mobil station. The Dennis Garage was torn down when the property was purchased by the town a few years back, and the recently completed Nobscusset Park now occupies this corner.

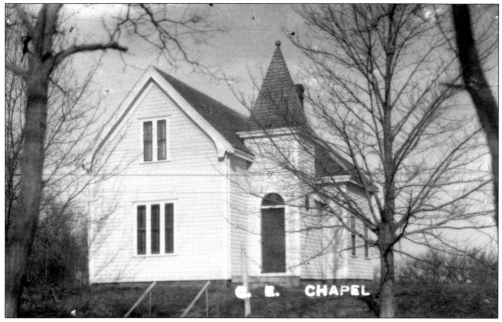

The Society of Christian Endeavor was started in 1881 by Dr. Francis E. Clark of Portland, Maine. Within a few years the popular organization had become international. Its mission, through a network of community chapels and youth fellowship groups, was to lead young people to a more spiritual lifestyle. The Dennis Christian Endeavor Chapel, standing at 854 Main Street, was built in 1893 and is now a private residence.

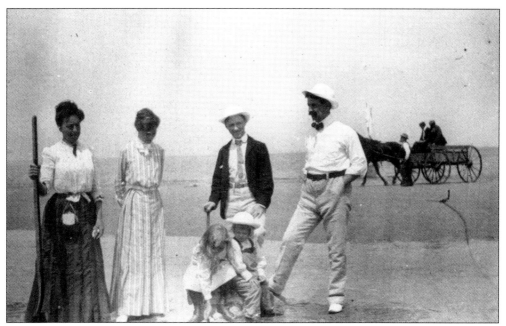

Here is a 1903 image of a family and friends spending a pleasant afternoon with the children on the sandbar at Corporation Beach in North Dennis. A horse and buggy appear in the background and is engaging in some early-1900s off-road activities.

Two

SOUTH DENNIS

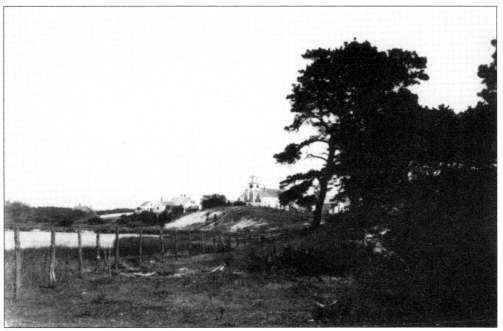

South Dennis was settled very shortly after the north villages and was the name originally applied to the entire south part of the town. Without a major east–west road running through it, fewer motorcar visitors tended to pass through this community while on route to their destinations. But, as the railway village of the town, it still experienced its fair share of tourism in the first part of the 1900s. Many Old Main Street homes were, at one time or another, offering rooms for travelers during this period.

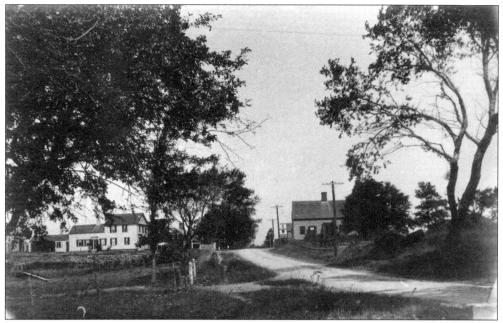

This vintage postcard displays the scene heading north on Old Main Street while approaching the South Dennis Congregational Church, which can be seen in the distance on the right side of the road. The home on the left no longer exists. The home shown on the right was moved nearby to Heirs Landing and is the first house on the right today as one proceeds up that street.

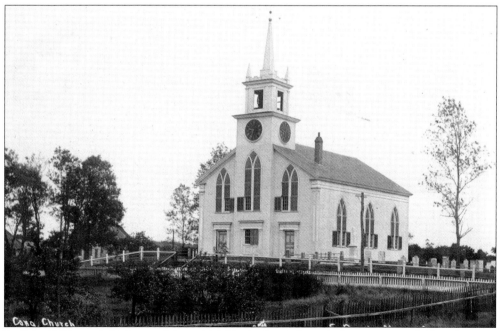

Built in 1835 at an initial cost of about $4,000, the South Dennis Congregational Church sits on the same site where the original Bass River Meeting House once stood in 1795, which was torn down when construction began on the present church. To help finance the cost of construction, many of the pews from the original meeting house were sold to raise funds.

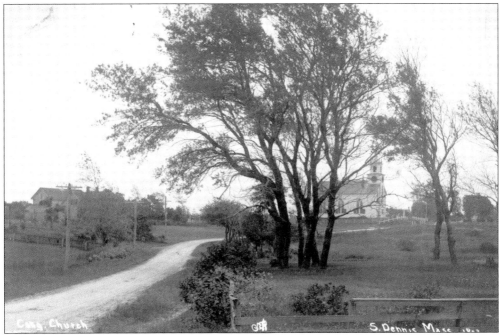

This historic church contains what is reputed to be the oldest playing pipe organ in the United States, which was made in London in 1762 by John Snetzler. It was purchased and installed here in 1854. Painter Edwin H. Blashfield's mural *The Adoration* can be found here, along with several other of his works, which were donated to the church by his widow in the late 1930s.

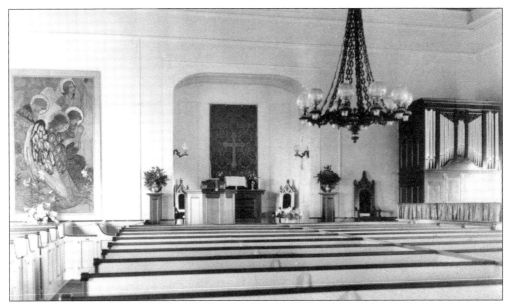

This interior view at the Congregational Church shows artist Edwin Blashfield's mural *The Adoration* on the left and the Snetzler organ on the right. A graceful chandelier originally powered by whale oil, but changed to electricity in the 1930s, is in view hanging from the ceiling. It was donated by the owner of the Sandwich Glass Works, who made similar donations to any Cape Cod church in need of a chandelier.

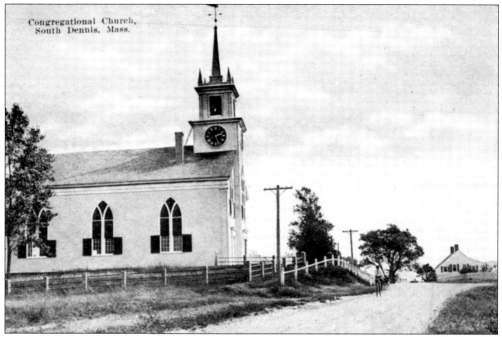

During the heyday of the maritime ship industry in Dennis, there were over 100 sea captains who were members of this church. The church building underwent an extensive renovation project in 1992, financed through a large community-wide fund-raising effort.

This older home is still standing at 248 Old Main Street, near the Congregational church. It was built in 1730 and was the original homestead of Capt. John Nickerson. Someone named Russell once lived here too and undoubtedly other families did also over its 277-year life.

This view is taken from Old Main Street and looking across the field to the Red Star Overall Company factory building (on the left) that was located on Cove Road, one of three overall manufacturers to operate in Dennis during a time when entrepreneurs here experimented with new industries. This business was owned by Eleanor Young and was built on her family's Cove Road land.

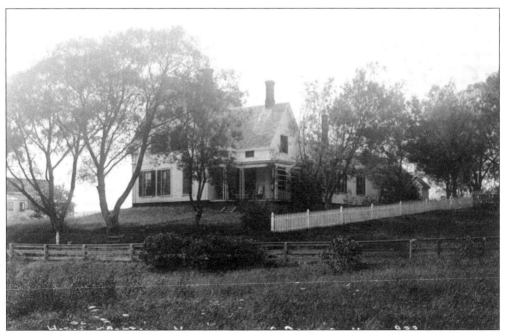

The original home of Capt. Ellis Norris was built in 1857 and is still standing at 9 Cove Road. Norris was master mariner of the schooner *Daniel Sturgis* during the time of the Civil War. He died in 1912 at the age of 90 years.

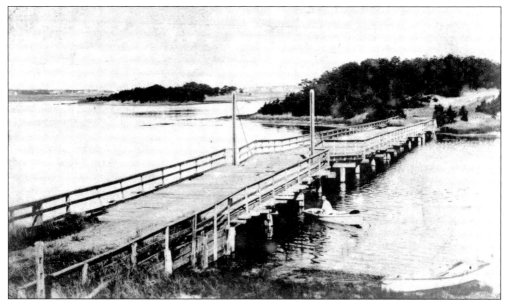

The Cove Road bridge for many years allowed people to traverse the Grand Cove portion of the Bass River. It was destroyed by ice floes in the river during the winter of 1905. West Dennis and South Dennis residents wanted the small drawbridge rebuilt very badly, since it was a tremendous shortcut allowing easy passage between the two villages. However, the remaining residents within other parts of town could not see how such an expenditure would benefit themselves personally all that much, and so a reconstruction was several times voted down. These two views (before and after damage) were taken from the West Dennis end of Cove Road looking across to the South Dennis side.

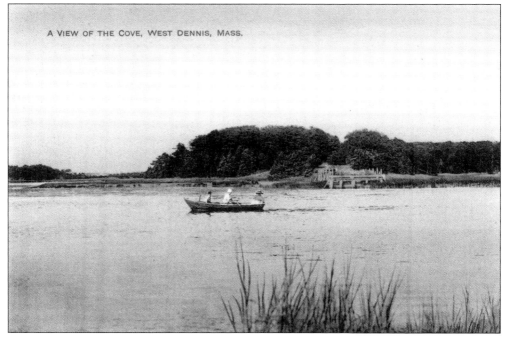

A VIEW OF THE COVE, WEST DENNIS, MASS.

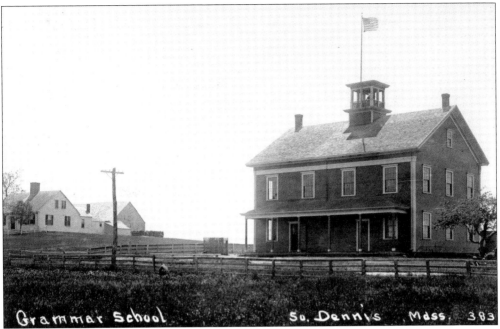

Grammar School So. Dennis, Mass, 383

The South Dennis schoolhouse was built in 1867 and was the Dennis High School from 1915 to 1931. In 1932, the Dennis Consolidated School was built (now Ezra Baker School) and it handled the grammar-school aged students from all villages in town. Beginning that same year, all high school students began going to school in Yarmouth, as they have ever since.

In 1932, the schoolhouse (on right in the distance) became the town's first fire station, operating as such until 1949. Then it was used as the town highway department garage up until the time the building was dismantled in 1956. Where the schoolhouse once stood is now property known as Salt Meadow Farm, and a plaque embedded in a stone marker there signifies the spot on the west side of Old Main Street where the school existed.

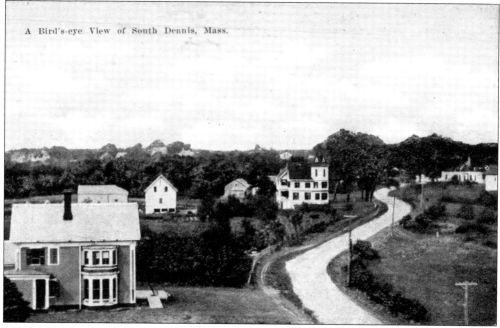

This is a view to the north from the bell tower of the South Dennis Schoolhouse, looking toward the point on Old Main Street where the previous picture was taken from.

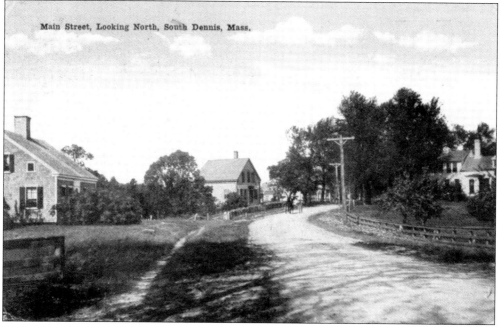

This postcard is of Old Main Street, looking north, showing the house at number 343 on the left. The house pictured in the middle is no longer in existence and the one on the right is the original 1839 home of Capt. Seth Nickerson. It is now known as Shady Hollow Inn, at 370 Old Main Street.

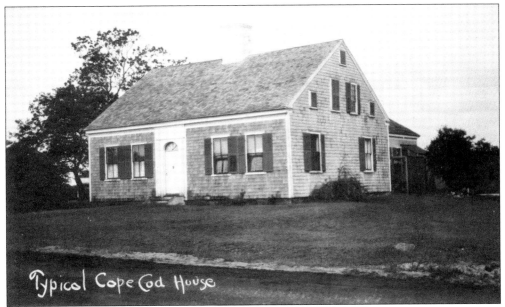

This postcard of a typical Cape Cod house is an example of a cape-style home, of which many were built. This one dates to 1808 and is located at 343 Old Main Street in South Dennis. It was once owned by Capt. Ebenezer Nickerson and later by Capt. Seth T. Wheldon.

The old South Dennis Post Office (on the far left) was located across the street from the onetime village skating pond, which is just beyond the fence visible on the right-hand side of the street in this vintage view facing south on Old Main Street. Said pond was then called Tobey's Swamp, and is now too overgrown for ice-skating.

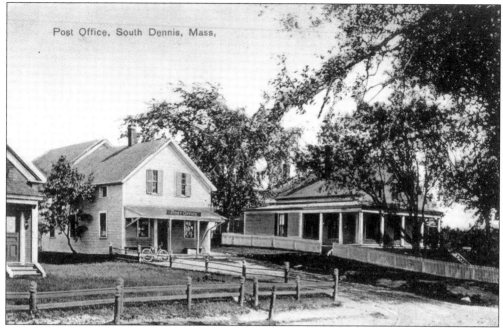

The post office started at this location about 1870, but the building is no longer there. The home pictured to the right of the old post office, which was built in 1846, is still standing at 390 Old Main Street across from the small pond. It was the home of former postmaster Marshall S. Underwood.

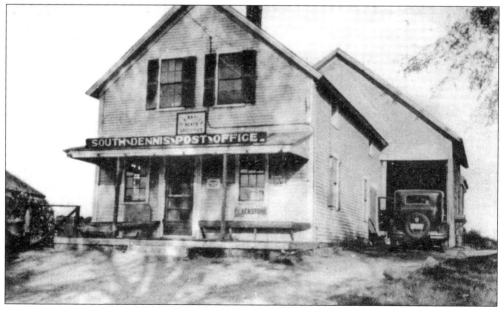

A village store was also in operation here for a period. Some meats and staples were sold, and it also featured a large candy case, the contents of which many a South Dennis child would view and long for. This location was for many years a focal point within the small South Dennis village, as it was not unusual to make three trips per day to collect the mail that arrived three times daily onboard the train.

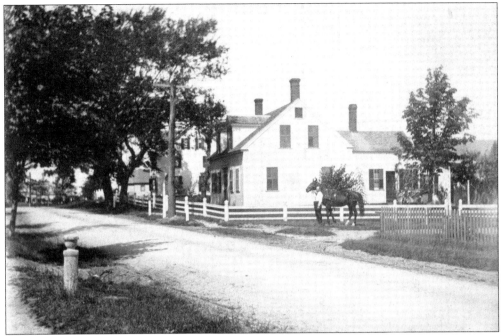

Here is a South Dennis resident showing off his prized horse outside of his (or his neighbor's) home, built in 1837 and now located at 430 Old Main Street. The home is on the east side of the road, two houses south of the Liberty Hall intersection.

A short distance further north from the previous picture, this 1908 postcard depicts the approach to the now busy intersection of Old Main Street and Highbank Road where Liberty Hall is located on the right.

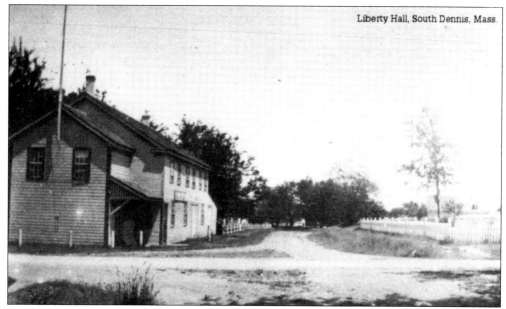

Liberty Hall, South Dennis, Mass.

Liberty Hall was moved by oxen to its present site in 1844 and has served the South Dennis community over time as a post office, school, dry goods store, assembly hall, meeting place, and stage coach shop. In 1990, a complete, historically correct restoration of the building was completed. Liberty Hall was gifted to the people of South Dennis by a former summer resident who once owned it.

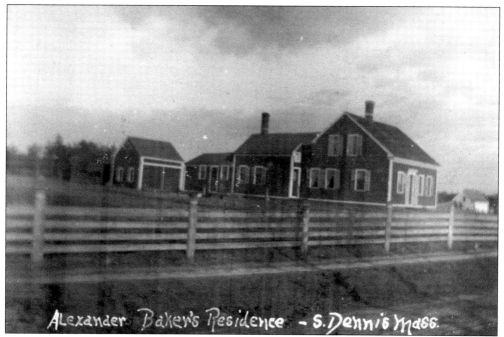

Alexander Baker's Residence - S. Dennis Mass.

The Baker residence, a three-quarter Cape built in 1836, is located at 16 Upper County Road and is across the road from Liberty Hall to the north. Original owner Watson Baker was postmaster at Liberty Hall during its early years as a post office prior to 1870, and he also served as town clerk and town treasurer.

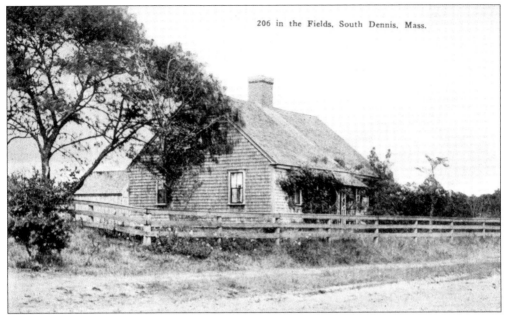

At 36 Upper County Road, adjacent to the Route 134 intersection, is the home pictured here. It was once owned by artist Edwin H. Blashfield (1848–1936), a talented mural painter who spent the later years of his life in South Dennis. Rather eccentric, he and his wife would regularly dress in Victorian-era clothing for their summer evening walks over and back across the Highbank Road bridge.

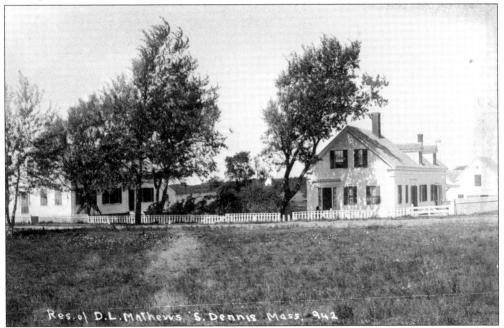

Res. of D.L. Mathews 'S. Dennis Mass. 942

This fine Cape-style residence was built about 1851 and owned by Capt. David L. Matthews. It is still located at 44 Highbank Road, which was formerly known as Bridge Street. There are several similar homes along this section of road. The photograph was taken some distance back in a field on the opposite side of the street.

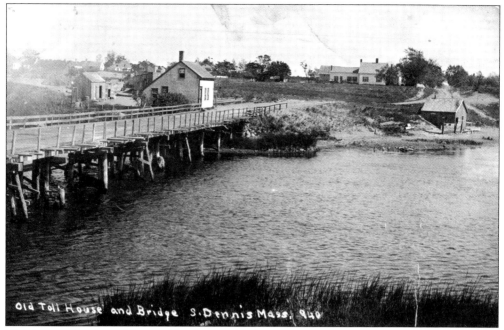

This is an early view of the Highbank Road bridge in South Dennis; looking west to east from the Yarmouth side of the Bass River. Tolls were often levied and collected back then as a way to pay for maintenance and upkeep of the bridges and as a means to recoup the construction costs. The tollhouse shown at the end of the bridge is now a private residence.

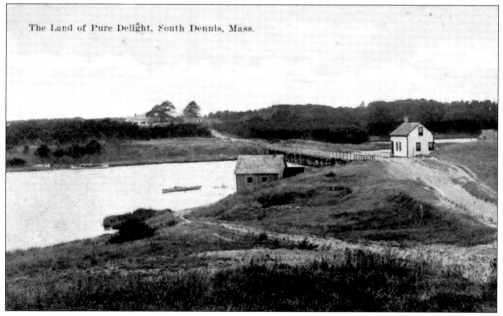

This second postcard view is of the Highbank Upper Bridge as it was then called (Bass River Bridge was called the Lower Bridge). Now the scene is looking toward the Yarmouth side of the Bass River, where today Wilbur Park is located immediately on the left after crossing over. The postmark date on this card is 1915.

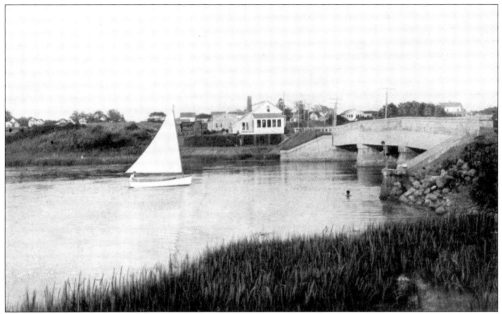

Here is another more recent postcard taken from the Yarmouth side of the Highbank bridge, now made of concrete in this picture. This newer bridge was built just slightly south of the former, thereby allowing travel to continue over the old bridge until construction was completed on the new one. Note the former tollhouse, which now appears more familiar as a residence.

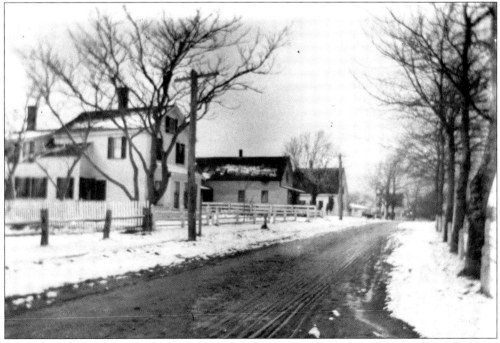

Before snow plowing rigs became widely used to clear roads as in this photograph, an early method was to roll the snow. This involved a large rolling pin–like device that would be pulled behind a team, compacting the snow on the road surface as the log shaped apparatus rolled over the top of the snow. Snow was also frequently used to fill potholes in the dirt roadways during winter.

Here is the home of Capt. Jeptha Nickerson, built about 1800. It is located at 447 Old Main Street and looks much different today from its appearance in this early postcard.

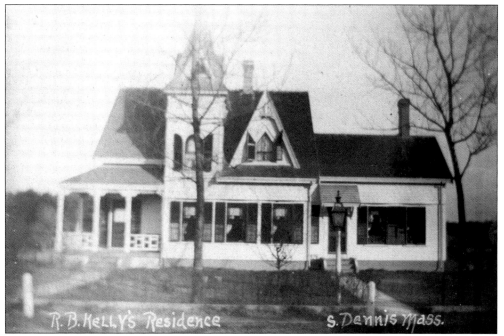

The attractive residence of Capt. Roland B. Kelley was built in 1891. He would often hold parties and gatherings of neighbors and guests, bringing lots of fruit back home for them on his return from sea excursions. His daughters would sing and play piano to entertain the guests. The home can be found at 480 Old Main Street.

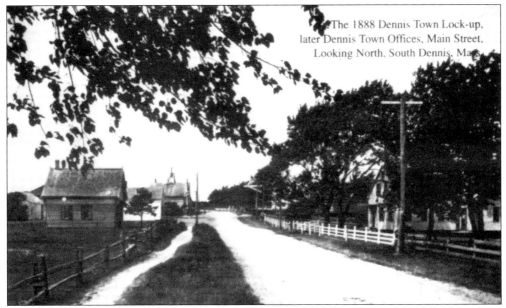

The 1888 Dennis Town Lock-up, later Dennis Town Offices, Main Street, Looking North, South Dennis, Mass.

Immediately on the left is a one room lockup, much like a small jailhouse, which stood where the town hall parking lot is now. It was moved elsewhere at about the time the present town hall was built in 1950 and has since been reused for both commercial and residential purposes. The lockup building is currently at 540 Route 28 in West Dennis, known as Cinnamon Sticks and Candlewicks gift shop.

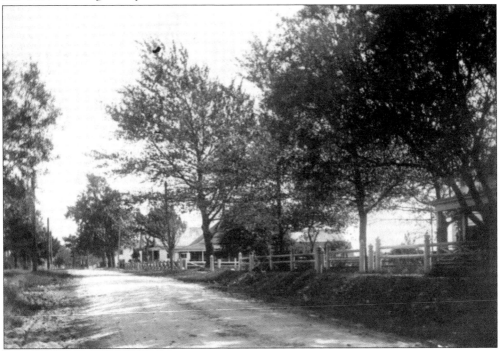

Here is an early-1900s postcard taken from nearly the same point on Old Main Street as in the previous picture, yet now looking south. This is from quite near the place where the town hall is now located.

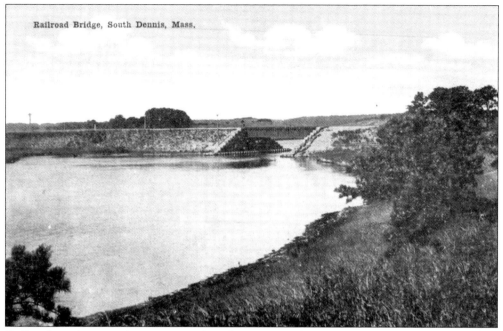

Railroad Bridge, South Dennis, Mass.

Railroad service started on Cape Cod in about 1848. The rail construction reached Hyannis by about 1854, and the railroad bridge depicted here over Bass River was completed in 1865, thus allowing passenger rail service to South Dennis for the first time, along with deliveries of coal, lumber, and dry goods.

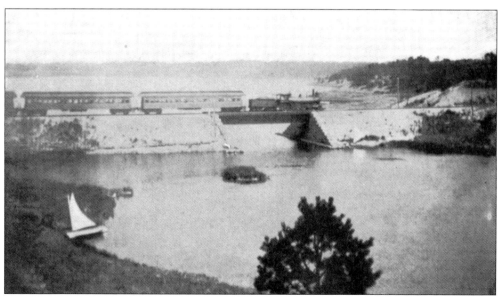

The advent of the railroad dealt a crushing blow to the livelihoods of many Dennis seafaring men in the late 1800s. It spelled the end of the packet ships and the business they generated for the ports in North Dennis and Dennisport and for the captains who commanded local sailing ships. The end of an era had begun as another one started, and Dennis found its principal livelihood suffering.

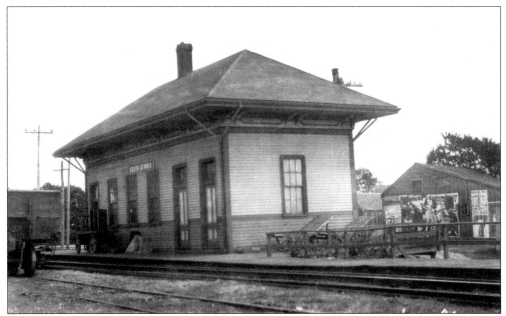

This South Dennis train depot was built in the late 1880s and was located at the very north end of the present town hall parking lot. Lives in the South Dennis village began to revolve around the three arrival times of the train each day, bringing its three mail deliveries and a variety of people who were coming and going. A trip to Boston from South Dennis was three and a half hours by train.

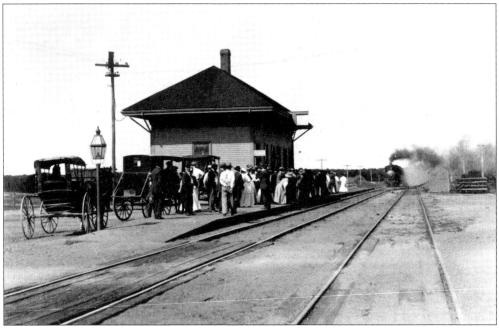

The automobile eventually exacted a similar fate for the rails as the rails did to the maritime industries. Passenger rail service to South Dennis ceased after 1939, although freight service continued for another two decades. The automobile also served to nurture the tourism industry here, which took off in the early half of the 1900s.

Here is a scene facing north on Old Main Street after crossing the railroad tracks and heading away from where town hall is now. A variety of supply businesses were once in operation here throughout the early 1900s due to the immediate proximity of the railway depot.

In 1918, Leon W. Hall started in business providing coal to local residents at a location near here on the east side of Old Main Street, steps from where the railroad tracks were located. Soon he branched out into a lumber business. Four generations later, Hall Oil Company continues its family's original fuel business. The lumber trade was sold in the mid-1960s, eventually becoming Mid Cape Home Center.

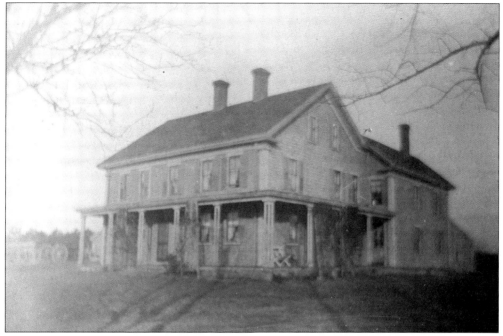

The River View Hotel operated near the railroad tracks as a convenient place for travelers and salesmen arriving by train to stay overnight before moving on to their next destination. The building has not existed for many years, since the 1930s, but it is said that it had a clear view down to Bass River from its Old Main Street location, due to the treeless topography of its day.

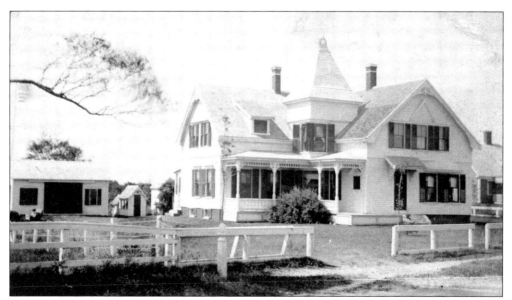

This home at 535 Old Main Street once belonged to Capt. Peleg Thacher. The home was built in 1890 but was subsequently destroyed in a fire. While sailing across Nantucket Sound and seeing the smoke in the distance on land, he was said to have remarked "That could be my house"; and he was correct. A nearly identical building was erected in its place, which is the home now found at this address.

Here is an early-1900s view of how Old Main Street looked as one traveled north, approaching the home (on the left) of Peleg Thacher that is shown in the previous postcard.

This is a familiar intersection to many Dennis residents. It is the view traveling north on Old Main Street at the point where Old Main Street forks off to the right and Old Bass River road begins at the left of the fork in the road. There was a directional sign at the crossroads then, just as there still is today. With an arrow pointing to the right, the sign reads "East Dennis & Brewster, 4 miles."

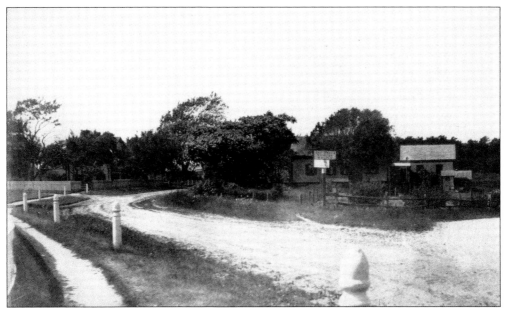

Here is another view of the same intersection shown previously. During the first half of the 1900s, if one took the left fork and passed what is now the Red Cottage there were virtually no homes along the way until one reached the North Dennis village. However, much longer ago, another village existed near the Old Chatham Road intersection that was named Middle Village.

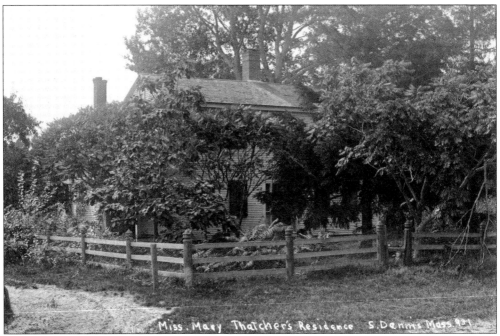

This home, obscured and overgrown, stood across from the Red Cottage restaurant and originally belonged to Capt. Lothrup Thacher. It was empty for many years in the 1900s, when this shot was taken, and was referred to as the "Haunted House." It became a rite of passage for local youths when they finally dared to attempt entry into the deserted structure for the first time.

This 1843 home and barn is at 506 Old Main Street, across the street from the present town hall parking lot. Its first owner was Capt. Moses B. Nickerson.

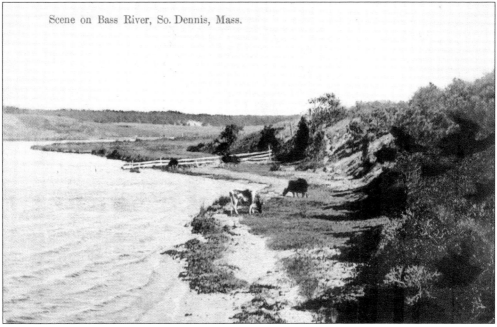

Scene on Bass River, So. Dennis, Mass.

Here is a peaceful 1920s scene looking south along the shores of the Bass River. Cows can be seen grazing on what is now called Wilbur Park, with the view of the South Dennis shoreline visible across the river. Those familiar with this section of the Bass River will note that the channel of the river here is now much different from its appearance in this postcard.

Three

DENNISPORT

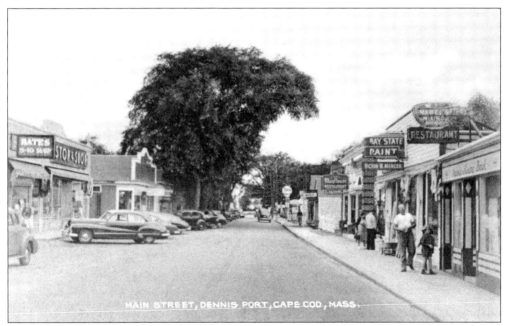

Once an active and vibrant seaport community in the 1800s, Dennisport (originally known as Crocker Neck) became the leading commercial and seasonal vacation destination found between Hyannis and Chatham as the 1900s progressed. It eventually relinquished its commercial standing in Dennis with the growth on Route 134 in South Dennis that occurred during the 1980s when Patriot Square and other establishments developed there.

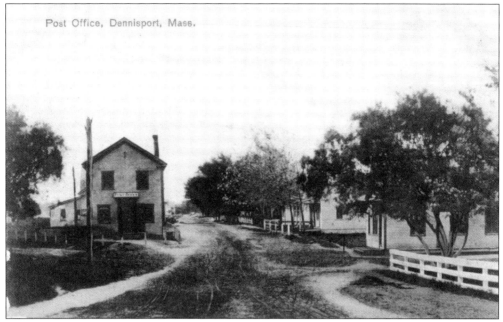

Traveling south from Route 28 on Depot Street will lead to the building that once housed the Dennisport Post Office from the early 1900s up to the 1920s. Originally a wheelwrights shop, this structure sits at the fork in the road as one arrives at the intersection with Pleasant Street when traveling south on Depot Street.

This postcard, titled *Post Office Square*, shows the building (still in existence, although much different in appearance) built by David Wixon that was in use as a post office during the 1920s and 1930s. It is located directly across from the entrance to South Street, along the north side of Route 28.

This is a scene looking north on Telegraph Road from Route 28, showing the building on the left that served as the Dennisport Post Office during the 1940s and 1950s. The gift shop Deborah Ann's Rainbow and the adjacent Dennisport Natural Market now occupy the corner. The east side of the road was then lined with impressive elm trees.

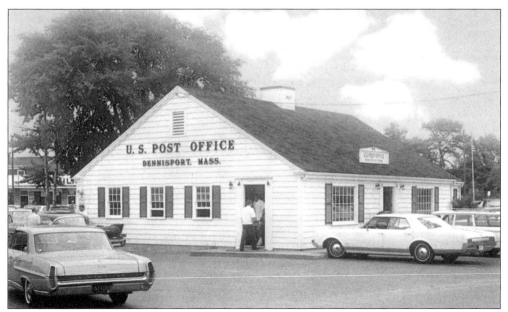

In 1957, this brand new post office building was constructed along Hall Street, adjacent to the municipal parking lot on the south side of Route 28. It remained in service as such through the 1970s, when soon thereafter the Dennisport Post Office moved to its present location on Mill Street.

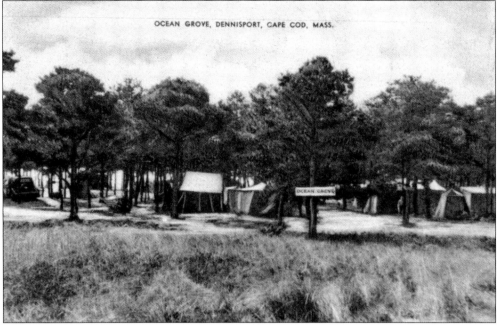

Many of the earliest summer visitors who first began to vacation in Dennisport with regularity were the school teachers and college instructors who had their summers off from their employment and some vacation time on their hands. Many of them would stay a good portion, if not all of the summer, camping in tents by the sea at the Ocean Grove campgrounds in the second decade of the 20th century and the 1920s. The tents would sit on wooden platforms beneath the pines along the shore, and it was an affordable way to live until they would then return to school in the fall.

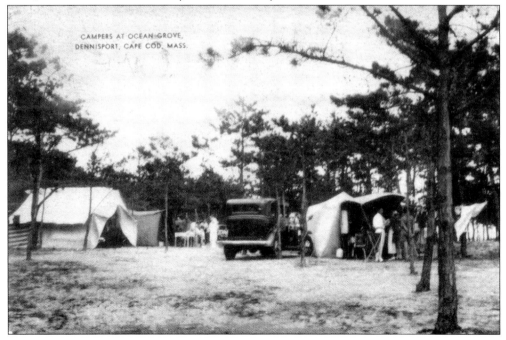

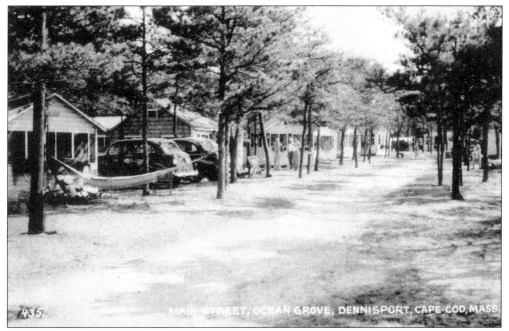

MAIN STREET, OCEAN GROVE, DENNISPORT, CAPE COD, MASS.

Eventually in the 1930s and 1940s, other frequent visitors to the campground areas joined the original campers and began to modify the platforms and surrounding environs, creating shanties and cottages upon the very platforms they had previously pitched their tents on. The Ocean Grove, Grindells, and Campers Haven came to evolve similarly in this way. Many people returned year, after year, after year to the campground communities that became seaside cottage colonies.

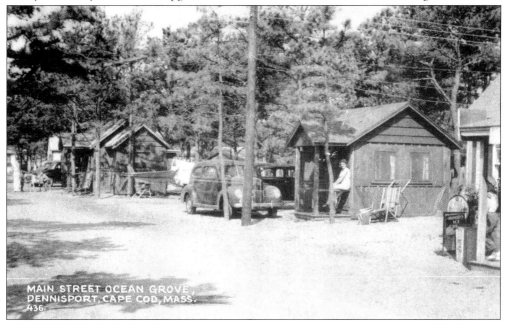

MAIN STREET OCEAN GROVE,
DENNISPORT, CAPE COD, MASS.
436.

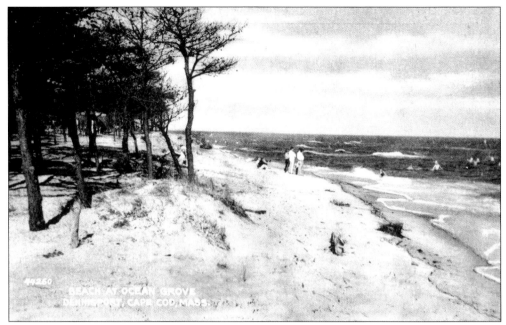

The pine trees were plentiful in several areas of Dennisport right along the shoreline, almost to the waterline. The powerful hurricane of 1944 that brought extensive damage to the area effectively eliminated all of this natural beauty. Many locals will tell that the 1944 storm dealt the south side of Dennis far more damage and destruction than the fabled Hurricane of 1938, an earlier storm that all have heard so much more about, yet was one of much less negative consequence to this area of Cape Cod than the 1944 storm was.

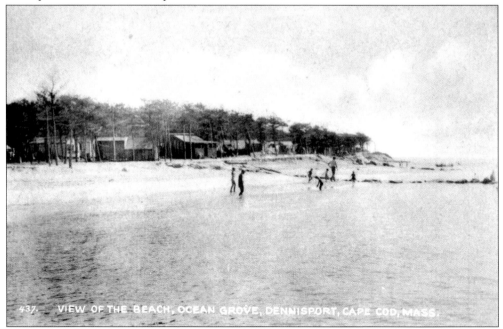

BEACH SCENE, DENNISPORT, MASS.

Here is a vintage Dennisport beach scene from about 1925. Residential development along the coastline was not popular nor viewed as a particularly prudent thing to do in those days because the heating and maintenance costs of keeping a home in such a location were prohibitive and out of reach for the average resident, not to mention the potential for storm damage.

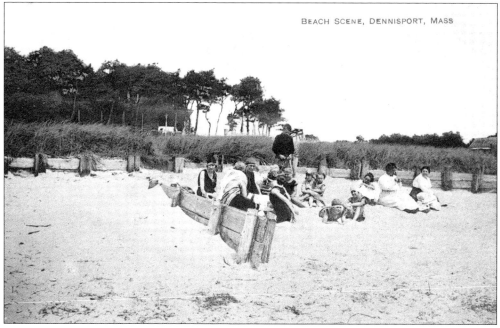

BEACH SCENE, DENNISPORT, MASS

In the early 1900s, swimsuits were not allowed to reveal arms, legs, or the neck, as it was thought to be obscene. As the 1920s approached, bathing wear slowly became less conservative, first uncovering the arms. Then the legs began to become exposed up to mid-thigh, and beneath the swimsuit legs were built-in "modesty shorts." Collars receded from tight up around the neck.

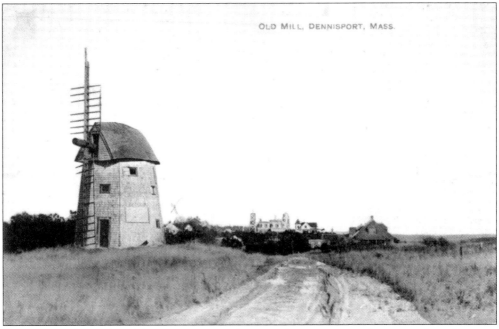

This windmill stood on Chase Avenue, nearly upon the exact spot where a small replica now sits at the Dennis SeaShores cottage complex and was casually used for many years as a bath house by beachgoers. It was a regular tradition back then to have a big bonfire on the beach the night before the Fourth of July, but in 1914 arsonists decided to burn down the windmill that evening instead. They succeeded.

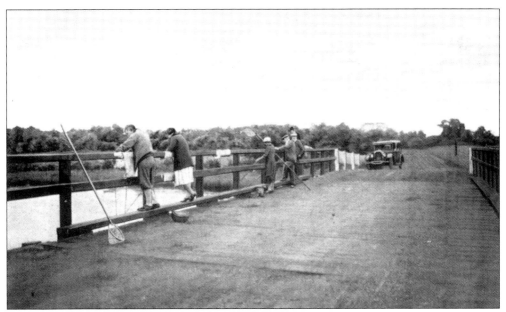

Here is a 1920s view of the bridge over the Swan River along Upper County Road. This was a popular fishing and crabbing location for locals and visitors. Adjacent to the bridge now is Clancy's Restaurant. Other restaurants from the past that once occupied this scenic river-view location included the Schooner Lounge and the Baitshop.

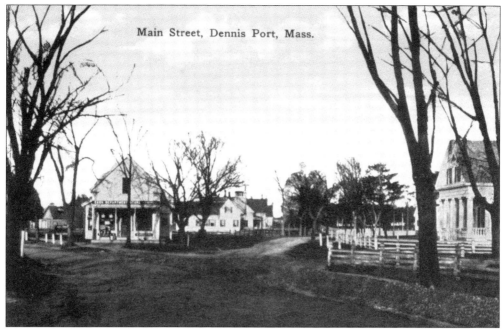

Main Street, Dennis Port, Mass.

Here is an early view, looking east, of the intersection of Route 28 (to the left) and Hall Street (forking to the right). The new Dennis Public Library (completed in 2005) is now located on the immediate right side of the road, where the white house is seen in this postcard. The business shown at the intersection was known as the Cash Department Store.

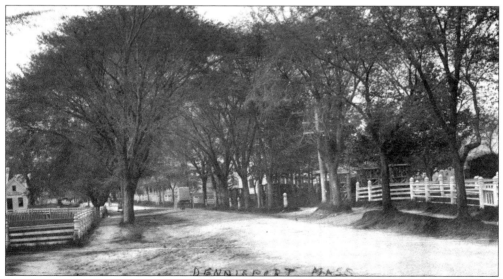

This picture is looking in the opposite (west) direction from where the previous one was taken, with the photographer's back to the Cash Department Store and the beginning of Hall Street on the left. There was once a sizeable residence here along the right-hand side of the main road. The barn from this property lives on as the nightclub known as the Improper Bostonian.

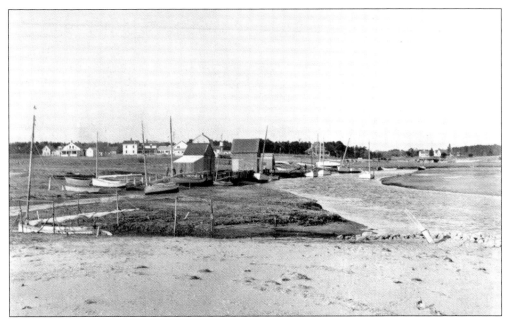

This view shows the Herring River in West Harwich, looking north from Nantucket Sound, where a tiny sliver of the Dennisport town line meets at this point. Dennisport fishermen who had boats in use would keep them in the Herring River, and some maintained the docks and fishing shacks similar to those shown here in this 1912 postcard up until the 1960s.

In the 1800s, several fishing piers extended out into Nantucket Sound from the shoreline in Dennisport, some as many as 600 feet in length. After an unforgiving coastal storm in 1888, only one such wharf remained for a short period of time. This postcard depicts a much smaller wharf, which may have been an accessory to one of the original larger versions.

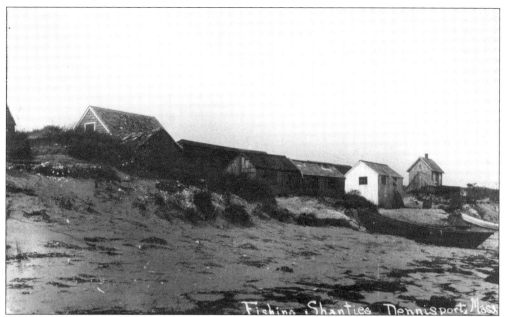

There were at one time many fishing shanties located along the shore in Dennisport and West Dennis. If not eventually destroyed by sea and wind, particularly the 1944 hurricane, many were hauled off the shore, and a few are now located in some of the back yards around the area and can be found in use today as sheds at some private residences.

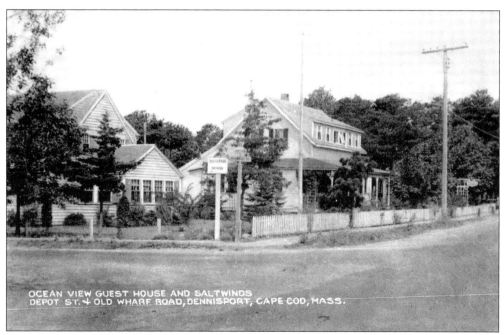

The Ocean View Lodge (right) and the Saltwinds (next door on left) at the corner of Depot Street and Old Wharf Road were a pair of lodging houses located a stone's throw from the beach. The Saltwinds is said to have originally been a ships chandlery shop at the pier once located at the end of Depot Street.

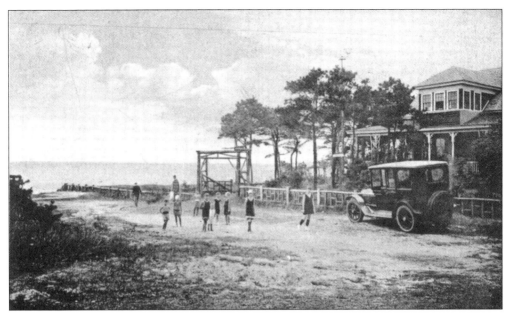

In the 1920s, at the very end of Depot Street this beach was in public use. The house on the right was owned by Charles Martineau. He ran afoul of the town when he deliberately tarred the beach in an attempt to prevent the coming and going of bathers. He claimed that the din of their noise was disturbing his afternoon naps on his porch.

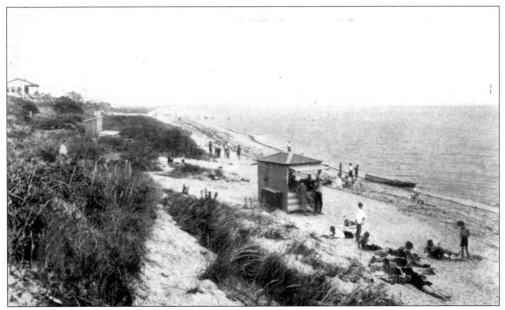

Here is the view, looking east, from that beach at the end of Depot Street in a 1930 postcard. It is a far different scene today with several businesses lining this section of the beach in Dennisport, among them more than a half dozen waterfront motels.

Sea Street Beach in Dennisport was as popular in the 1940s as it is today. The town acquired several of its most popular waterfront holdings on both the north side and south side of town between 1930 and 1950. This was a shrewd move by the Town of Dennis, ensuring ample beachfront areas to draw summer visitors to the community.

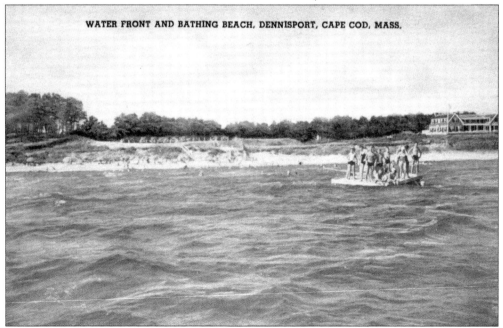

In past years, many of the beaches in town on Nantucket Sound and Cape Cod Bay had a raft or float anchored off the shore each summer for the enjoyment of the beachgoers. In Dennisport, the raft pictured here off the Sea Street Beach was built, maintained, and hauled in and out each season by a generous local builder.

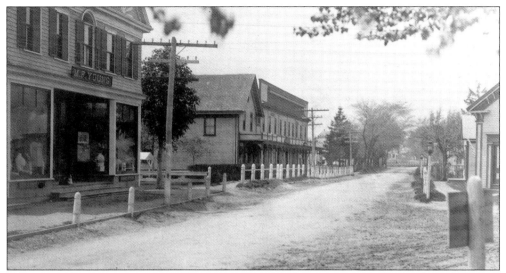

Here is a vintage postcard showing how the main business district of Dennisport that is now known appeared in the very early 1900s. The view is facing west, with the row of buildings depicted here being along the south side of Route 28. The large building in the middle of the street belonged to local physician Dr. David Ginn of Dennisport.

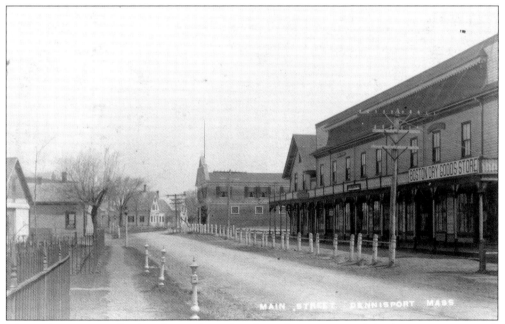

This is the same stretch of road again but taken from the opposite end, looking east. Dr. Ginn's Block, as it was called, housed many businesses, including his own pharmacy, a stove shop, barber, mercantile, dry goods, billiard room, and hardware store, among others. Up ahead at the bend in the road is the point at which Upper County Road comes in from the left and meets Route 28.

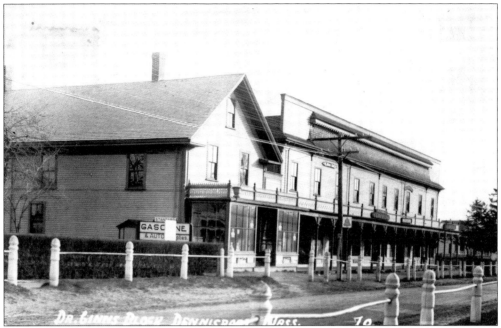

When gasoline powered automobiles began appearing, the town required Ginn to dispense gasoline out in the back of his building, rather than out on the main road, because the town was concerned that an unexpected clash of new and old transportation technologies would occur, believing that the smell of gasoline would greatly startle the horses.

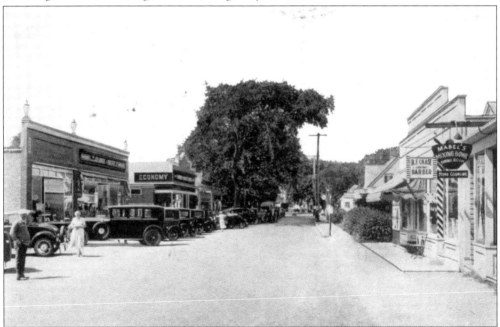

The Ginn block was completely destroyed during a 1931 fire that had started in a merchant's wastebasket. New stores and buildings were quickly rebuilt in its place in the 1930s, shown here along the left (south) side of the street. Businesses had also begun to appear now along the north side of the street.

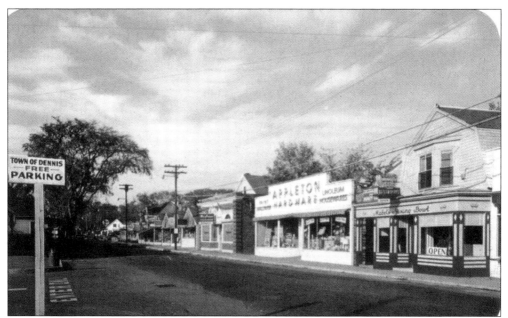

The first two longtime businesses shown on the right, Mabel's Mixing Bowl restaurant and Appleton's Hardware, were eventually torn down in order to build the gas station that now exists at the Upper County Road and Route 28 intersection. The third building in from the right, once known as the Mayflower Restaurant, has since been the home of BZ's Pizza for over 20 years.

Main Street, Dennisport, Mass.

This view is the northeast corner of Route 28 and Depot Street and is currently occupied by Barbo's Wayside Furniture. The large house no longer exists, but the barn on the left in this photograph is still on the property. It has been turned 45 degrees and is attached to the rear of the furniture business. The old Cape-style house is the next property shown, and that building now sits on Phyllis Lane, off Old Bass River Road in South Dennis.

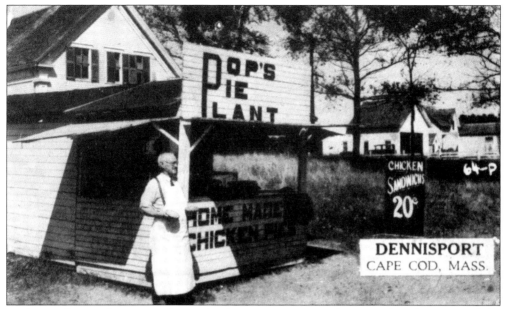

Pop's Pie Plant, a downtown fixture in the 1920–1940 period, operated in the center of the commercial strip. E. A. "Pop" O'Brien baked his chicken pies in the open air of his stand on a pair of simple three-burner kerosene stoves topped with steel enclosures. The back of the postcard boasts "over 40,000 pies made at this stand over the past eight years." Longtime locals do not question the validity of the claim.

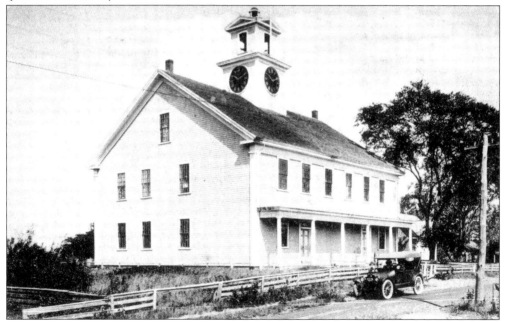

The Dennisport schoolhouse had served many other uses on Nantucket before it was dismantled, floated over, and reassembled here. The schoolhouses in North, South, East, and West Dennis built between 1859 and 1867 were then patterned after it and appear nearly identical. This was the only one with a clock, however, because there was no church steeple in Dennisport sporting one, as in the other villages.

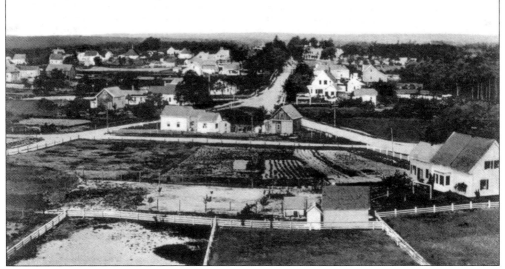

Dennisport, Mass. Looking West.

These next few postcard views were taken from the cupola tower of the Dennisport schoolhouse. This first one shows the west view with Route 28 proceeding from the lower right and then curving straight off toward West Dennis. Sea Street runs straight across the picture, side to side, and Mill Street is the third road, running from the lower left and proceeding until it meets Route 28 at the fork in the road. Christy's Market now sits at that fork in the road.

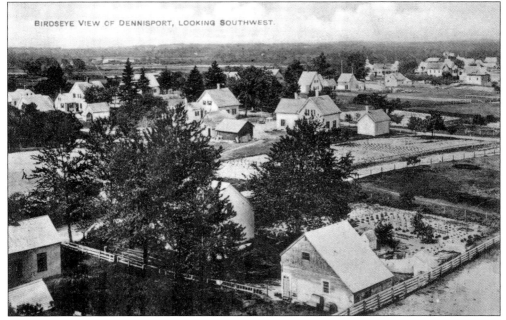

BIRDSEYE VIEW OF DENNISPORT, LOOKING SOUTHWEST.

In this picture view peering southwest, one can see what was once a large asparagus field owned by Elijah Robbins. Much of his crop he sold to the Belmont Hotel in Harwich for use in the meals that they prepared there for their guests. The asparagus field ran nearly the entire length of Mill Street from Sea Street to Depot Street. Asparagus was then an excellent cash crop for many Cape Codders.

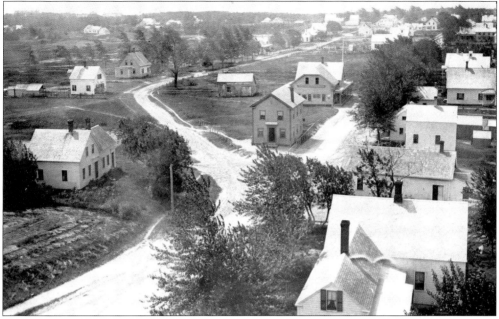

This view is from the top of the schoolhouse while looking to the South toward Nantucket Sound. Pleasant Street forks off to the left, and Depot Street to the right. The old post office building sits facing the camera, at the fork in the road.

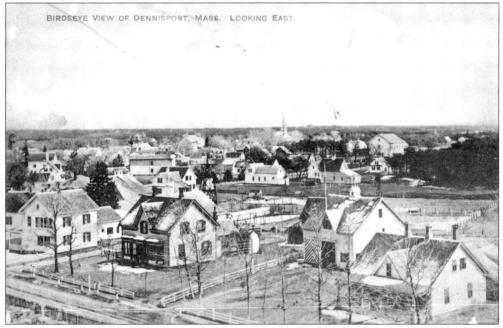

BIRDSEYE VIEW OF DENNISPORT, MASS. LOOKING EAST.

The direction of view is now east-by-northeast and encompasses the primary stretch of businesses located on and around Route 28 at the center of Dennisport. Off in the distance the church located on Main Street in West Harwich can be seen in the neighboring community. A fire destroyed the Dennisport schoolhouse in the early 1930s where these postcard pictures were taken from.

The Village Improvement Club (VIC) building on Depot Street was built on the very spot where the Dennisport schoolhouse had previously stood. The VIC was a social club, and construction of their building was financed through a unique fund-raising effort. Framed photographs were produced picturing the Dennisport schoolhouse that were offered and sold for $1 a piece, with enough money raised in the process to complete the entire building.

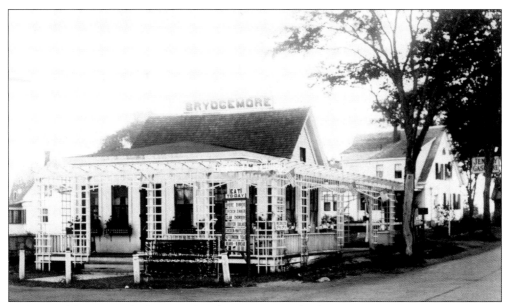

Ladies would go out and take tea in the afternoons at establishments such as the Brydgemore Tea Room, although tea room was usually just another name for a restaurant in those days. Some of the items advertised on the sign in front include: "Shore Dinner," "Lobster Salad," "Chicken with Waffles," and "Beans and Bread." Bob's Best Sandwiches and Catering is now operating here, on the corner of Route 28 and South Street.

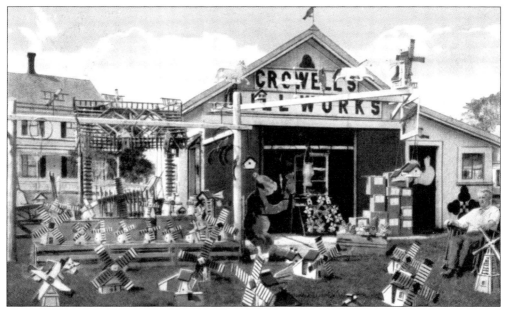

Across the road and on the opposite corner of South Street and Route 28 was the location of Atherton Crowell's Toyworks/Millworks. His was one of several early souvenir shops that sprung into action as summer visitor began coming to the area, offering whirligigs, windmills, and whatnot. Interestingly the business now located here, Pizazz, and several others that preceded it, have also specialized in merchandise geared to the summer tourism trade.

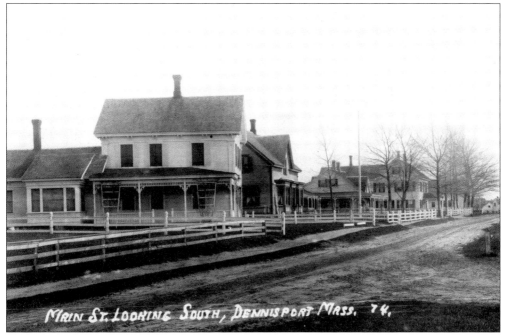

The first home pictured on the left can be seen when first turning onto South Street from Route 28 and is now a business known as Pastiche Botanica, located at 8 South Street. The other buildings beyond it on the left-hand side are no longer there. In their place now stands the Salt Works Village Condominiums complex.

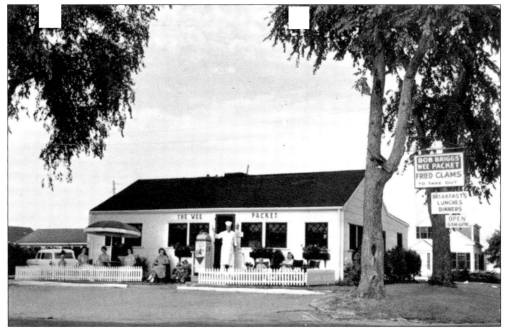

The Wee Packet Restaurant began in 1949 when owner Bob Briggs was 23 years old. He and his wife continued the business there for 54 years before retiring. It is said that the converted cottage was made from lumber and timbers salvaged from a fish wharf that once stood along the shore. Briggs was a charter member of the Dennis Chamber of Commerce, and coinventor of the Dennis Festival Days.

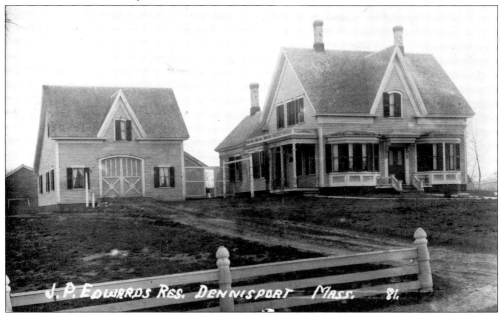

Jonathan P. Edwards was a highly regarded figure in Dennisport during the first part of the 20th century and owner of a huge fish wharf that once stood at the end of Sea Street. His attractive home, seen in this 1913 postcard, was located on the south side of Main Street, Route 28. This location is familiar to many nowadays as the Stage Stop Candy store, at 411 Main Street.

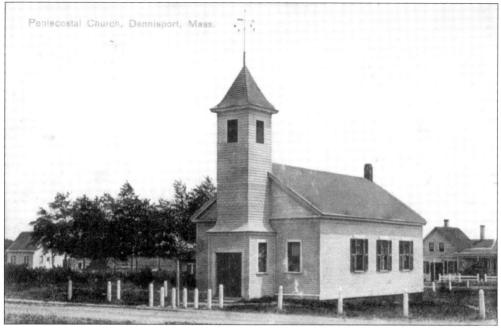

This chapel was originally a Baptist church located in the town of Harwich. After many years of service to that community, it was subsequently moved here to the east side of Depot Street, south of Route 28, becoming the original home of the Church of the Nazarene (incorrectly labeled as Pentecostal). Now at this location is the brick church known as the Mid Cape Assembly of God, at 142 Depot Street.

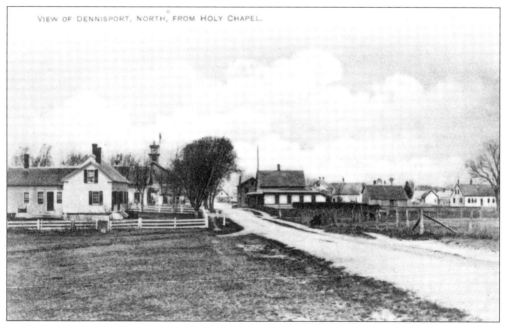

This photograph shows how it once looked when facing north from the old Church of the Nazarene along Depot Street. In the distance the clock tower of the Dennisport schoolhouse is visible, as well as the old post office building on the Pleasant Street corner.

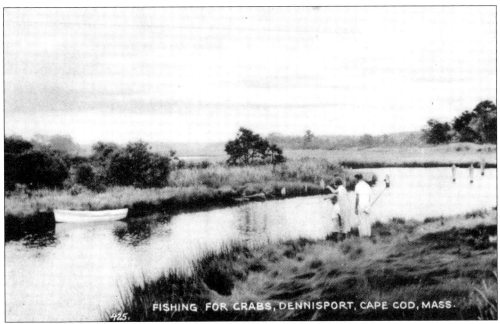

FISHING FOR CRABS, DENNISPORT, CAPE COD, MASS.

This 1940s postcard was taken near Route 28 along the Swan River, which was famous for crabbing and the large Maryland blue crab was the prized catch. The southern shores of Cape Cod were the farthest north that these crabs would migrate, and back then they were plentiful here. Dangle a piece of string or twine, wait for the crab to latch on, then pull it out and drop it into a net or a bucket—it was that simple.

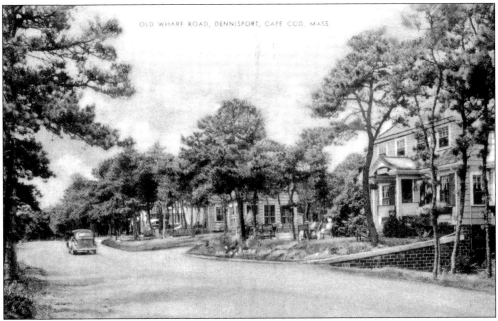

OLD WHARF ROAD, DENNISPORT, CAPE COD, MASS.

Old Wharf Road is the main drag running along the beach in Dennisport. Many a local young man in his first automobile has cruised this strip on a hot summer night and used a variety of pickup lines designed to lure the vacationing young girls visiting from off-Cape, which has led to this road's infamous, decades-old nickname, "Snatch Alley."

Four

WEST DENNIS

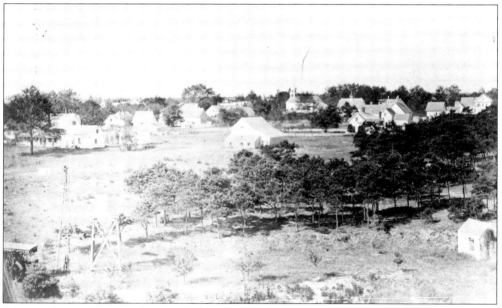

One section of the West Dennis village was originally known as Crowe Town, due to the numerous descendants of early north side settler John Crowe that came to live here and the surrounding area. Eventually these descendants adapted the surname spelling of Crowell. Another section of West Dennis was called Bakertown after the numerous Baker inhabitants living there. Many from these families, and their fellow West Dennis neighbors, achieved great success in the maritime trades.

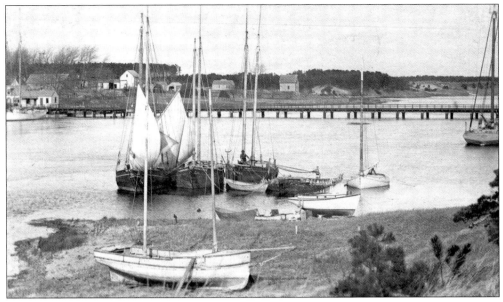

Prior to 1832, passage over the Bass River from Dennis to Yarmouth was accomplished by ferry. It was time-consuming and inconvenient; with foot passengers, livestock, horses, carriages, and commodities all crammed onto a slow, wobbly flat-bottomed boat operated by ropes and pulleys. Finally a toll bridge constructed of wood connected South Yarmouth and West Dennis and remained in use for many years as shown here in these two early-1900s postcard views, both of which were taken from the West Dennis side of the river.

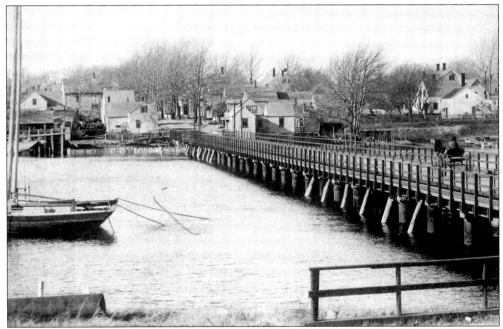

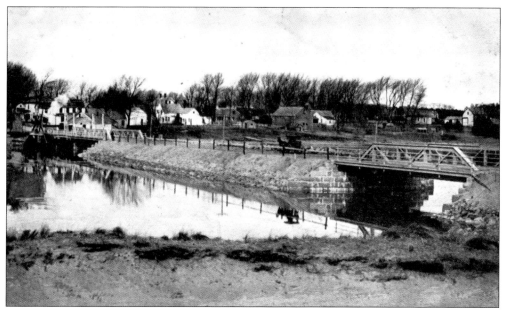

Early after the beginning of the 20th century, the Army Corps of Engineers designed and built a new bridge. This second version featured a man-made island in the middle section of the river which was created from fill that had been hauled in for the purpose. The steel construction West Dennis side of this bridge (on right in top photograph) was stationary, while the Yarmouth side (on left in top photograph) was equipped with a drawbridge to allow ships to pass through. It turned out to be a poor project design, as the man-made island caused shoaling within other nearby parts of the river. The lower photograph is taken from the island facing the Yarmouth side. The tollhouse is in view at the end of the bridge on the right.

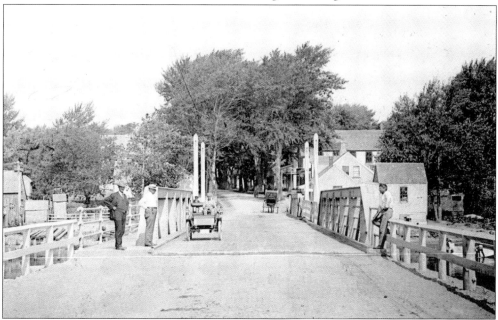

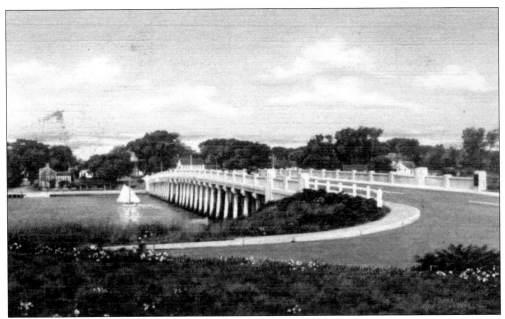

The third version of the bridge, constructed of concrete as it is known today, was completed in 1935. The man-made island from the previous bridge was removed from the river, and the excavated fill was hauled to the Dennis side of the river. It was deposited on the north side of Route 28 between the roadway and along to the river's edge, effectively creating an upland area. After many commercial property uses at the site over many years, the Town of Dennis recently purchased the parcel with a planned use as a conservation area named Bass River Park. The upper postcard is looking toward Yarmouth and the bottom is looking toward Dennis.

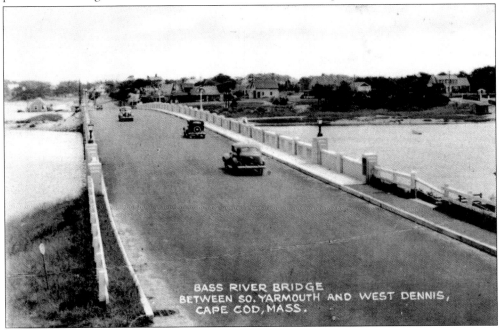

BASS RIVER BRIDGE
BETWEEN SO. YARMOUTH AND WEST DENNIS,
CAPE COD, MASS.

Here is a Main Street view, approaching the School Street intersection from the east. The lower sections of the trees along the roadside appear to be white in color. This whitewashing of the trees was a common practice, before the days of streetlights, which allowed for the horse and buggies to travel at night and find their way along the roads through the darkness.

An idyllic street scene, taken from the intersection of Main Street and School Street in West Dennis, is facing an easterly direction on Main Street toward where the previous postcard picture was taken.

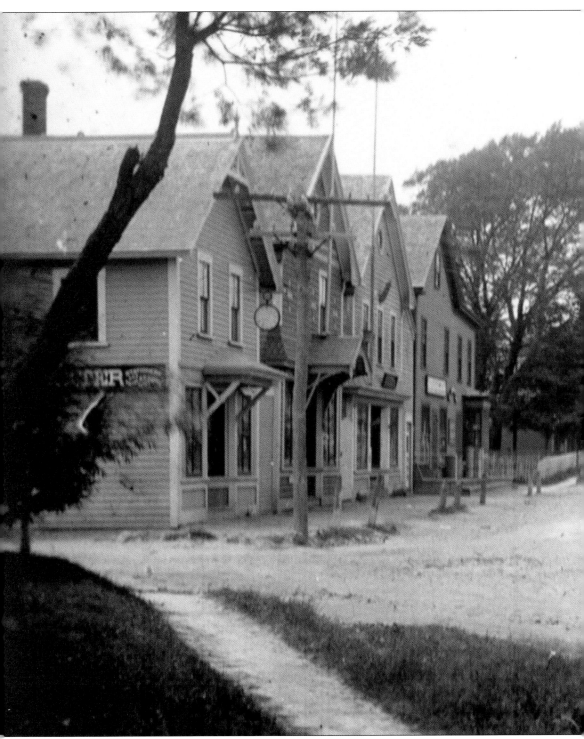

Here is the commercial center of West Dennis as it appeared in the late 1890s and early 1900s. The view is looking west along Main Street, Route 28. The street on the left joining the main road is School Street. The photographer's carriage can be seen parked a short distance up the road on

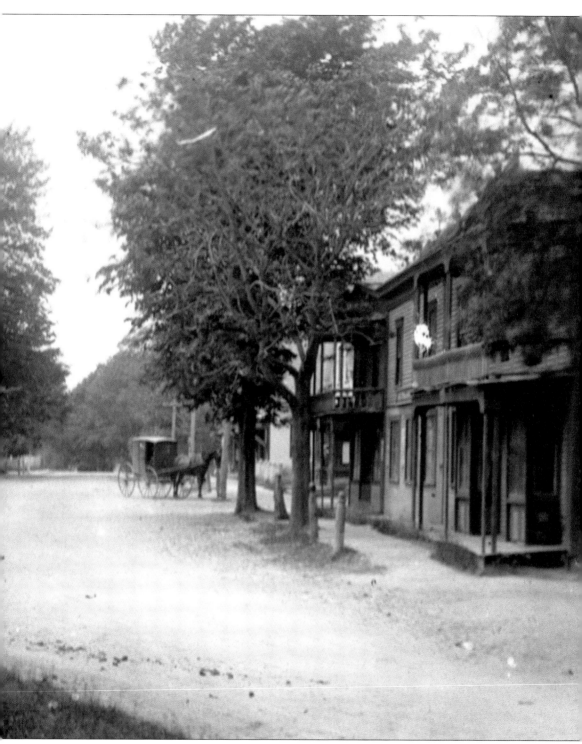

the right side. Some of the establishments of that time seen here include a furniture store, a stove dealer, tinsmith, apothecary, bootsmith, and clothing store. The Baxter building immediately on the School Street corner advertised "Stationery and Yankee Notions" on its sign.

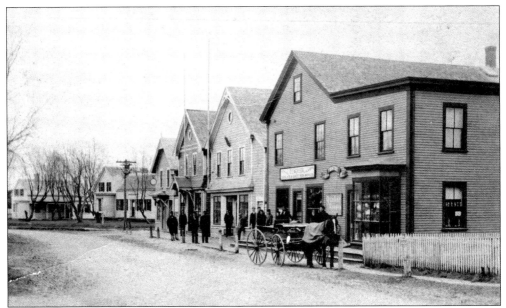

This is another view from the same late-1890s to early-1900s period, looking east at the same set of buildings found in the previous photograph. School Street is on the right just after the forth building. The second building is the only one of these four still standing, and when passing by it, a sign high up on each side of the building can be seen regarding the Knights of Pythias, a fraternal organization that held meetings here.

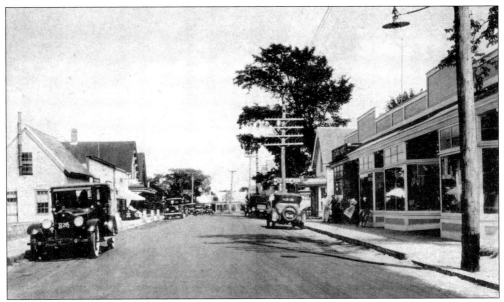

A later postcard from the 1920s shows the view from further down in front of the church, again looking east on Main Street. The storefront on the right (south) side of the road was new then and looks much the same today. The first two buildings on the left side are also still in existence.

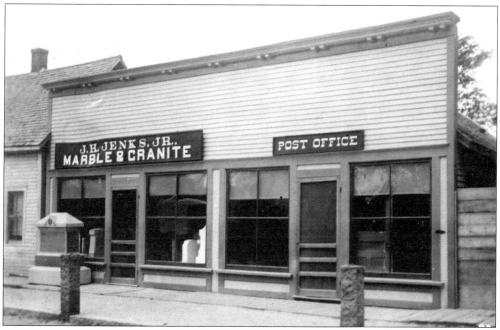

This is the second building in on the left in the previous postcard and looks fairly similar in appearance today. Not only was James H. Jenks the postmaster here at this Main Street location, but he was also the local provider of marble and granite tombstones, operating both from within the same building. Undoubtedly he could be considered as an early visionary in the art of multitasking.

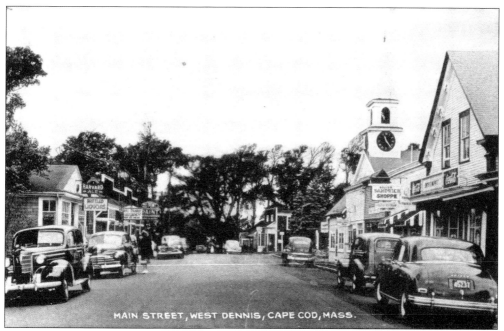

A western-facing view of Main Street, still later in time, shows automobiles and plenty of businesses and visitors on a busy day in West Dennis.

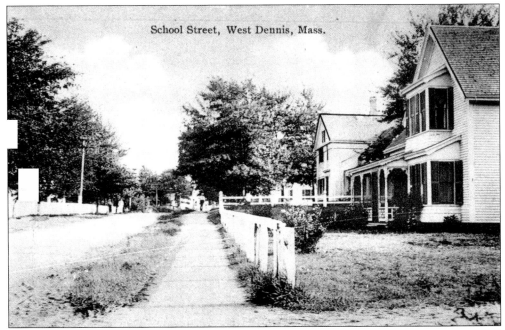

Turning south on to School Street from Main Street in the early part of the 1900s would have appeared as it does in this postcard. The first home on the right no longer exists today, but the second one still stands.

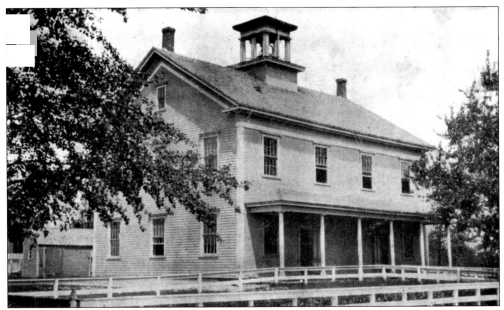

The West Dennis Graded School, built in 1867, is the only one of five such schoolhouses built in Dennis that is still standing. It served many other purposes over time after its life as a schoolhouse. A large restoration and fund-raising effort in the late 1990s restored it to its former glory, and a rededication ceremony was held in October 2000. The author's daughter sang the national anthem to kick off that day's festivities.

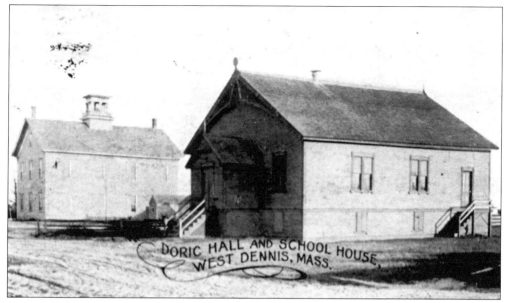

Doric Hall (right) was once a private school originally known as West Dennis Academy and was located elsewhere in the village. When moved to the location shown here, in close proximity to the West Dennis schoolhouse (left), it served primarily as a meeting place for a variety of community activities. It was torn down many years ago and is no longer in existence.

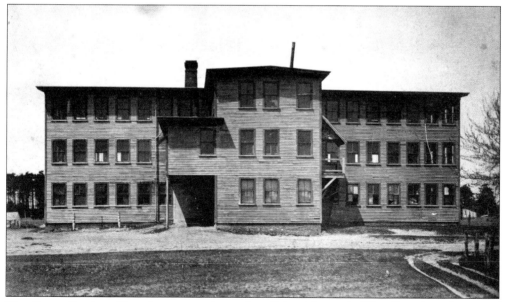

The Casey Brothers Shoe factory was located on School Street in West Dennis at the site of the present post office building and operated for a period of time during the 1890s. A large manufacturing facility located a good distance out on Cape Cod that was far away from the competition and markets proved difficult to sustain, and it was not a long lived business.

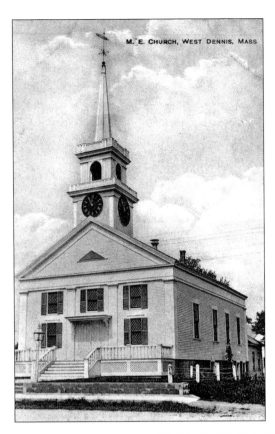

The West Dennis Methodist Church was built in 1835 after 10 years of planning and fund-raising at a reported project cost of $1,188. The land upon which it was built at the corner of Church Street and Route 28 was donated by Capt. Elisha Crowell. In 1873, through affiliation it became known as the Methodist Episcopal Church. It is today known as the West Dennis Community Church.

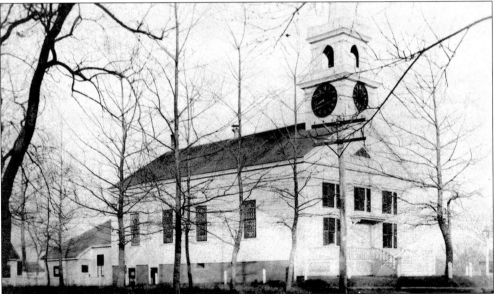

As the congregation grew, a larger church was needed. It was decided that the most cost effective way to do it was to cut the church in half, move one part to the north, and then build a new section in between. Another notable event here was the powerful 1944 hurricane, which blew the steeple clear off of the church, piercing a hole through the roof as it came to rest point down.

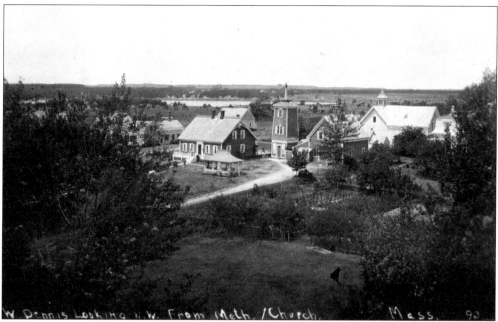

As the caption indicates, here is an older panoramic view in a northwesterly direction from the top of the Methodist Episcopal Church on Main Street. Bass River is visible in the distance and a fairly treeless vista beyond. The tower depicted here once housed an observatory and telescope, being located upon one of the highest points of land along the south side of town.

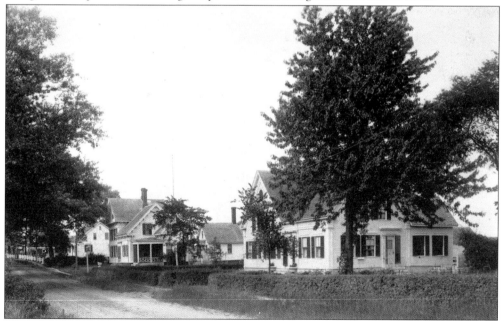

This early-1900s card shows the first three homes located on Church Street. A home on this street was an excellent location for a seafaring man, due to its close proximity to Bass River, in addition to being only steps from the church and Main Street. The second property, at 24 Church Street, has been converted to condominium ownership. The third is the 1810 home of Capt. Elisha Crowell.

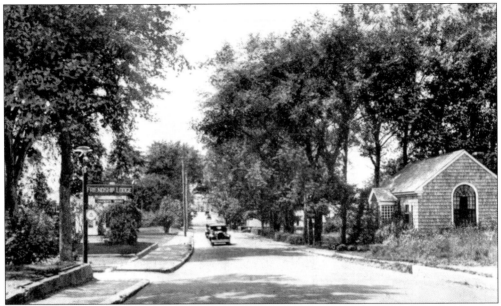

Here is a view from about 1930 looking west along Main Street from the Church Street intersection. On the right is the old West Dennis Library. Although the library has since moved to larger quarters nearby, the building still exists in the same location.

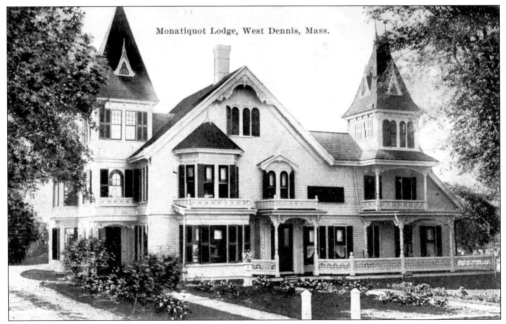

Monatiquot Lodge, West Dennis, Mass.

This impressive building sits directly across the street from the old library mentioned previously, at 275 Main Street, Route 28. As the former home of Capt. Luther Crowell, it first welcomed the influx of summer visitors as the Monatiquot Lodge in about 1910. It also operated in subsequent years as the Elmhurst Inn and the Friendship Lodge. After several years in use as a private residence, it has recently reopened again for lodging as Cobblestone Bed and Breakfast.

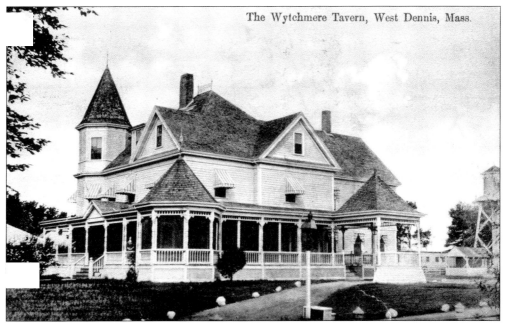

The Wytchmere Tavern, West Dennis, Mass.

Another home that opened its doors to the burgeoning tourism industry, which the advent of the automobile brought here, was the Wychmere Tavern. Built in 1894 as a summer home by Col. H. B. Winship, he nicknamed the property Wincove, likely due to its proximity to Grand Cove. It operated in later years as the Elmwood Lodge and is now a private residence located at 57 Old Main Street.

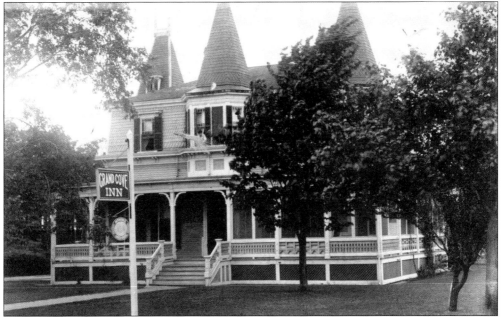

The Grand Cove Inn, with it triple-spired roofline, was another popular stop off point for motorists exploring Cape Cod in the early days of tourism here. Located at 520 Route 28, the building was converted to the condominium form of ownership some time ago and is just steps from the shore of Grand Cove.

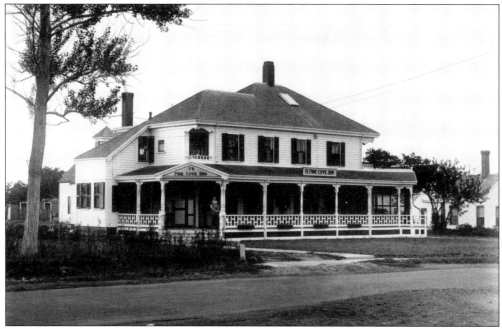

The Pine Cove Inn, situated at the Old Main Street and Route 28 intersection in West Dennis, was another large home (built in 1860) that was formerly owned by sea captains and became a lodging destination for the blossoming tourism industry in the early part of the 1900s. This was likely one of the oldest same-named businesses in town prior to its closing at the end of 2006.

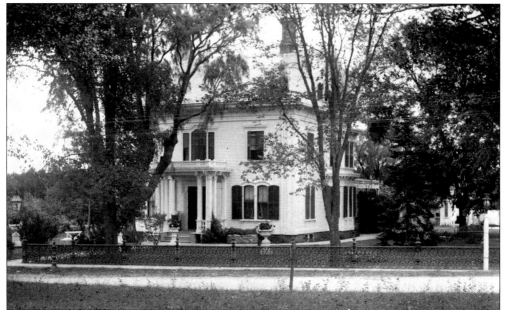

Here is the 1861 home of wealthy sea merchant Capt. Obed Baker. His daughter inherited the home and used it as her summer residence. This early postcard shows the home before she added large, two-story columns to the front of the structure around the front door, which led to the building eventually becoming referred to as the Columns. The property was a popular restaurant and jazz club for many years.

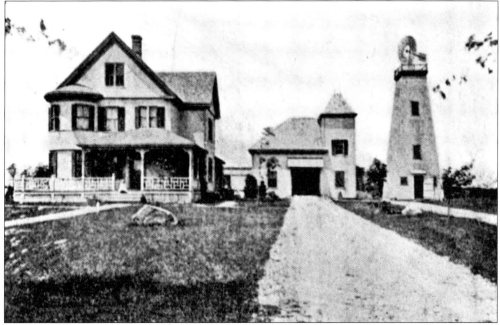

Dr. Horatio Kelley's 1892 home on Route 28 is pictured here. In addition to inventing a "headache cure," Kelley was an early supporter of building a canal through and beyond Bass River, rather than through Buzzards Bay, that would connect Nantucket Sound with Cape Cod Bay. Boston Blinds is now in business at Kelley's former 416 Main Street property.

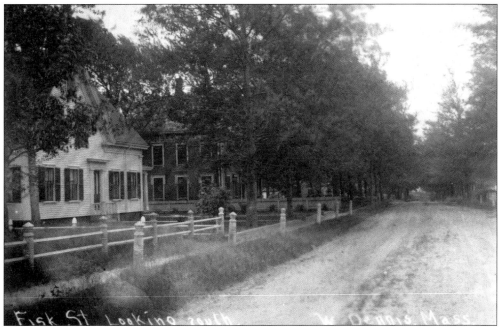

Here are neighboring homes built in the mid-1800s located along the east side of Fisk Street. Both homes are still in existence at 76 and 82 Fisk Street, just south of the cemetery on that street. The street was named after the prominent West Dennis fathers and sons of that name who were highly regarded mariners.

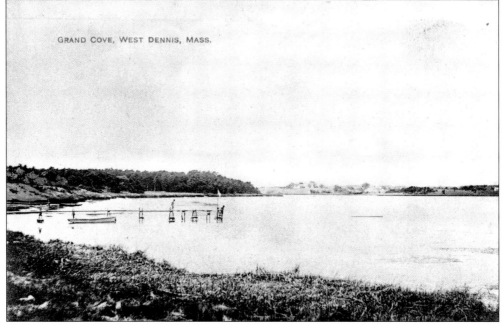

GRAND COVE, WEST DENNIS, MASS.

Grand Cove offered the men owning smaller boats a safe place to keep their craft during the winter months. Often they would haul them from the water to the shore and make necessary repairs and spruce them up in the spring. Grand Cove has for many years been a rich area for shellfishing pursuits. The postmark on this card reads 1914.

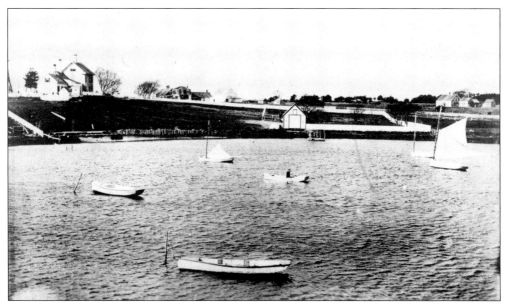

This early-1900s postcard depicts a view of the part of the southwest end of Grand Cove that is known as Little Cove.

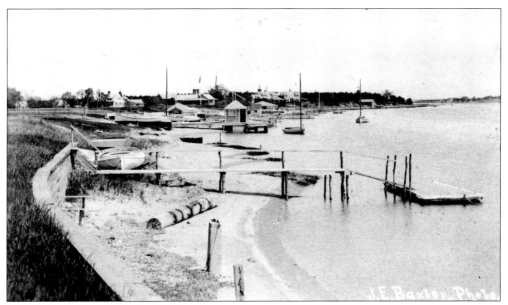

This early-1900s postcard is a shoreline view along the Bass River. Packet ships would regularly arrive at wharfs that were once located on these shores, bringing passengers, food, supplies, and mail from other ports. Some salt works enterprises also once existed here in the past, as well as flakeyards for processing fish.

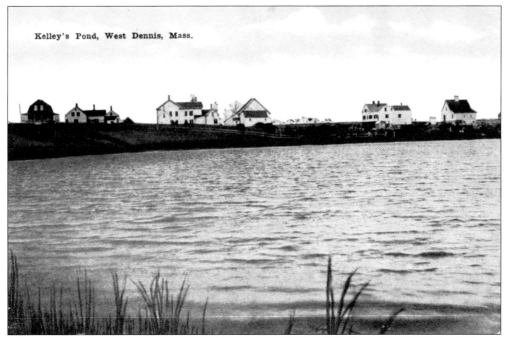

An icehouse and ice-making business existed on Kelly's Pond during the winter months, as it did on Scargo Lake and the other freshwater ponds in town. The ice-harvesting process was very labor intensive, often requiring many men for the one to four weeks of work time required, depending on inclement weather and snow removal. With the widespread advent of electricity and refrigeration, these businesses declined drastically in importance during the 1940s.

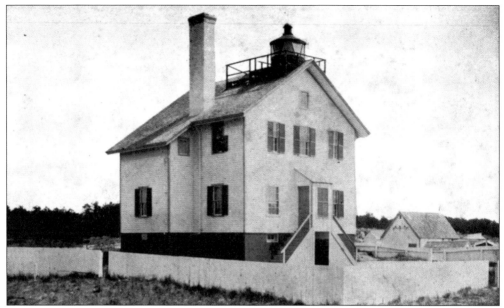

The Bass River Lighthouse on West Dennis Beach provided a navigational marker for ships returning to port on the south side and for those traveling through Nantucket Sound in transit between New York and Boston. However, with the opening of the Cape Cod Canal in 1914, travel time between these cities became greatly reduced, and the Bass River Lighthouse was decommissioned from active service.

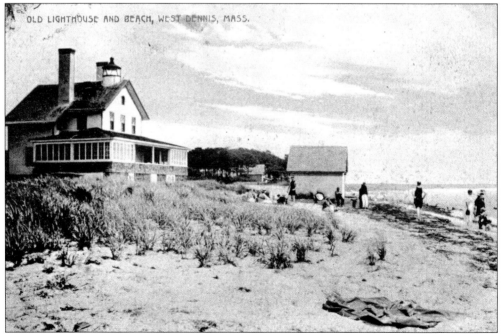

OLD LIGHTHOUSE AND BEACH, WEST DENNIS, MASS.

This early postcard shows a view of the lighthouse, which was built in 1855, and the beach area it rested upon. The small shed, referred to as the oil house, was used to store the fuel oil that was used to keep the flame burning within the beacon area of the lighthouse, providing the light for passing ships.

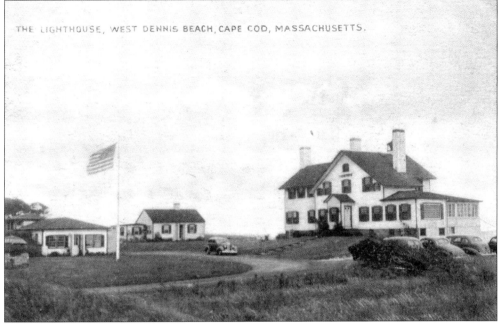

In 1938 the lighthouse began its long run as a popular resort when the Stone family acquired it and began operations here at what became known as the Lighthouse Inn. Owner Robert Stone was a founding member of the Dennis Chamber of Commerce and coinventor of the Dennis Festival Days, and the Stone family continues to operate the business today.

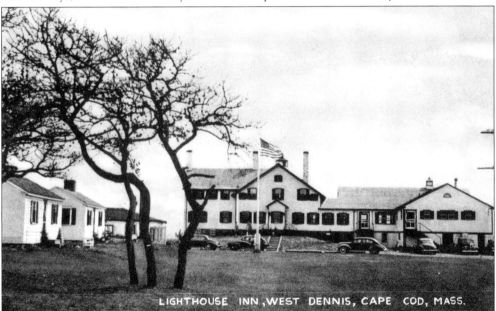

LIGHTHOUSE INN, WEST DENNIS, CAPE COD, MASS.

In 1989, the U.S. Coast Guard granted the Lighthouse Inn a special permit to reoperate the light atop the establishment. For the first time in 75 years, since the 1914 decommissioning, the Bass River Lighthouse was able to shine once again and does so every six seconds between the months of May and November. The year 1989 was also another anniversary of sorts, marking the 200th year since lighthouses had first begun to operate on American shores.

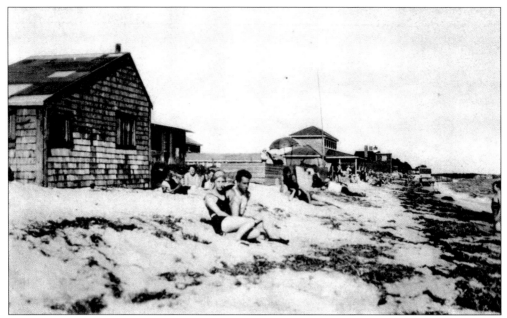

In this West Dennis beach scene the Bass River Lighthouse can be seen furthest in the distance on the shore, a bathhouse that once existed is in the middle distance, and a fish house shanty (of which there were many individually owned along West Dennis Beach) is closest in view.

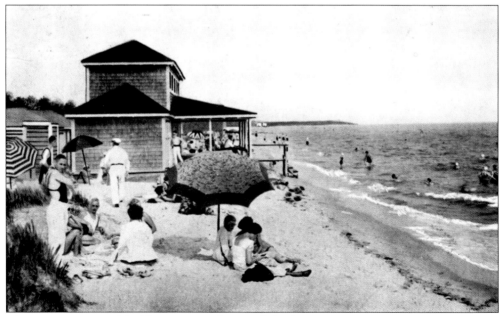

The West Dennis Beach bathhouse was used primarily by the summer visitors. The vacationers could rent a locker here for a day or week to use throughout their stay to provide a place for a change of clothes and swimsuits while at the beach. The bathhouse was lost during the 1944 hurricane.

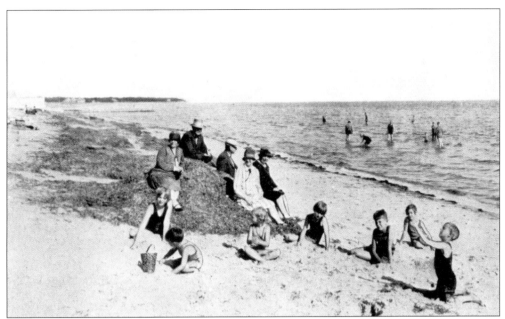

The bathing suits shown in these older pictures were made of wool. They became extremely heavy when wet and water laden, and they also were notoriously itchy and irritating to the skin. Adults generally did not spend large amounts of time at the beaches as is common today. More often they would stop by for bathing, as it was called, and perhaps a picnic.

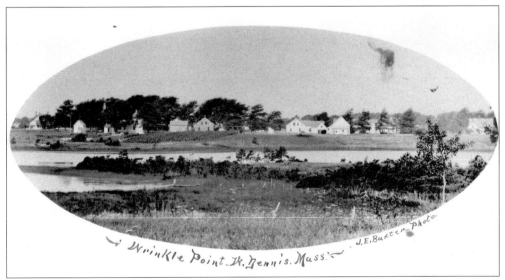

This is an early postcard view of Wrinkle Point in West Dennis, with the view looking across the Bass River to homes along the South Yarmouth shoreline.

A roadside business designed to attract passing motorcar tourists, Baker's Windmill Shop (and Lessard's Windmill Shop before it) sold hand-carved souvenir windmills, whirligigs, and other such clattering devices, much like a similar business in Dennisport. The building is now known as Breezy Knoll Cottages at 159 Route 28. As this is written there is still a windmill contraption or two out front!

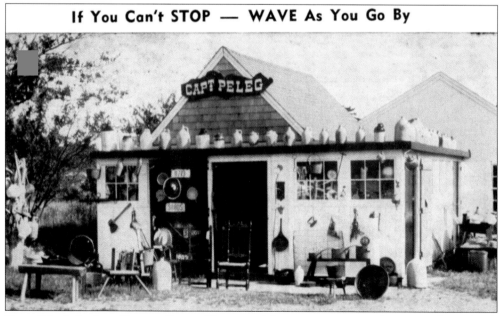

Capt. Peleg's Antique Shop on Route 28 operated for many years near the Ezra Baker School, offering attic treasures to tourists passing by on their vacation and sightseeing trips.

Five

EAST DENNIS

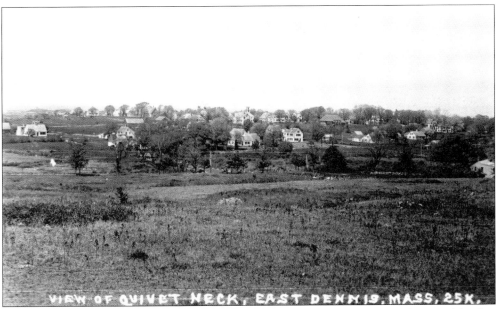

VIEW OF QUIVET NECK, EAST DENNIS, MASS, 25K,

East Dennis was different from the other Dennis villages in that it was the only one of the five that did not have a main road running through the heart of it as the other ones did. This led to a somewhat more segregated lifestyle for the residents there in Quivet Neck. The area was sometimes referred to in very early years as Searsville, due to the large number of people bearing the surname Sears that lived in the Quivet village.

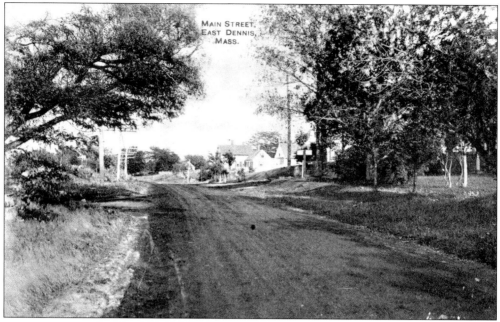

MAIN STREET,
EAST DENNIS,
MASS.

The now-busy intersection of Route 134 and Route 6A was quiet in the 1920s in this postcard, looking east and approaching Route 134 (which is on the right, just beyond the white road sign). The first home on the right that is seen today after passing the Cape Cod Co-Operative Bank is visible in the distance in this photo postcard, at 1613 Route 6A.

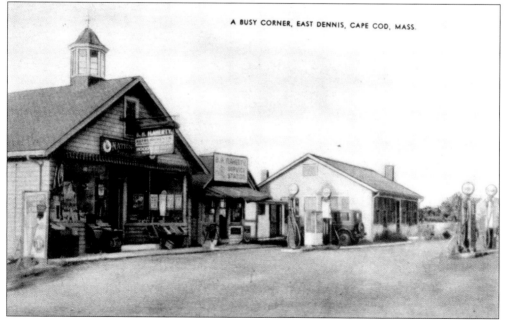

A BUSY CORNER, EAST DENNIS, CAPE COD, MASS.

This was the scene on the corner of Bridge Street and Route 6A in the 1930s, and it remained similar in appearance up until the 1960s when Players Plaza was built. The Flaherty store (left) immediately on the corner was moved further down on Bridge Street and became the Marshside Restaurant. A Shell gas station was built and ran here from 1968 to 2002 and has now become commercial office space.

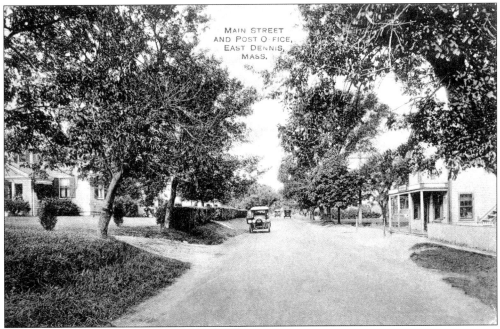

From the mid-1920s, this is a view looking west on Route 6A where the old East Dennis Post Office stood for many years on the right (north) side of the road. On the left is a *c.* 1790 Cape house, which was extensively restored recently. Located at 1661 Main Street, the business at this address it is now known as Fox and the Firefly Home and Garden Accents.

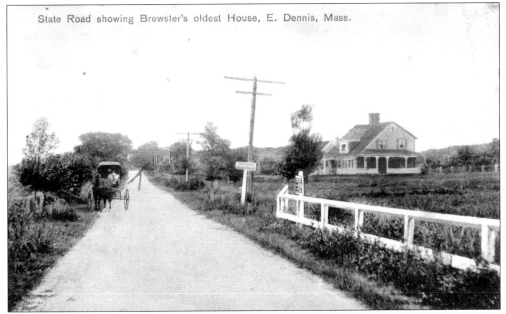

Here the photographer is standing on Main Street near what is now the Airline Road intersection and is facing east toward Brewster, where this antique home from 1719 still stands, but slightly different in appearance today. Although technically in Brewster, the photographer was standing in East Dennis when the picture was snapped (as evidenced by the sign indicating the town line), thus the somewhat confusing caption.

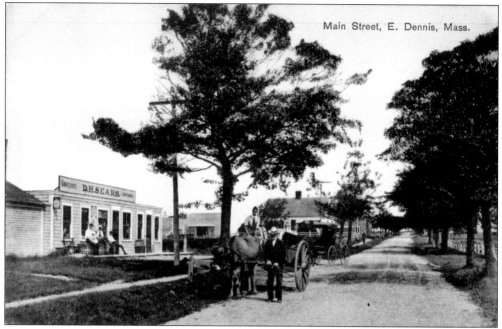

Here is a view of the dusty roads within the Quivet village of East Dennis before automobiles became common here. A pair of carriages appear to have pulled over for a stop in at the D. H. Sears store, which was located on the west side of School Street. The store, long since gone now, operated within the heart of the village from the late 1800s up into the 1950s.

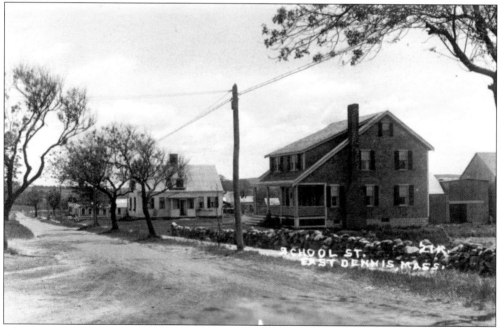

This shot is from the other end of School Street, looking south toward Main Street. The two most prominent homes here on the west side of the road are still in existence. The third building in the distance was the old D. H. Sears store, which was lost in an early 1950s mid-day fire whose billowing smoke could be seen as far away as Seaside Avenue in North Dennis.

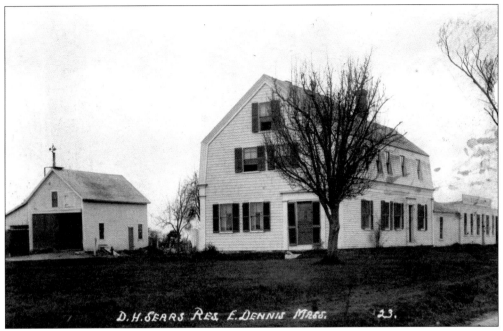

This was the home of D. H. Sears in the early 1900s on the corner of South and School Streets. Originally built as a single story home, the second story was added at a later point in time. At the far end of the building the local store bearing his name is visible. The home was just recently taken down and a new residence has been built in its place.

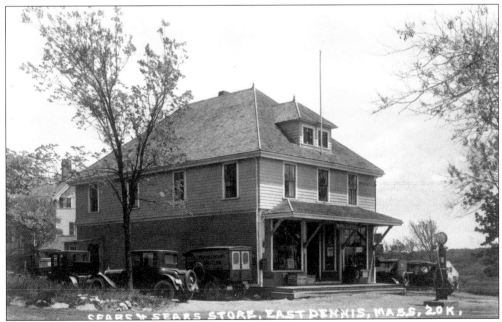

Another store that conducted business within the Quivet village in the early part of the 1900s was known as Sears and Sears, which was run by descendants of early-1600s East Dennis settler Richard Sears. The building, still in existence now as a private residence on the corner of School Street and Center Street, offered groceries and other general store items of the day.

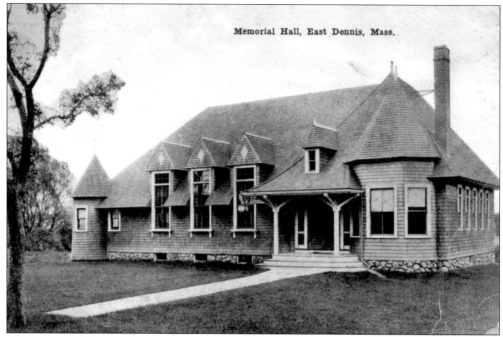

Memorial Hall, East Dennis, Mass.

These postcards show what was then called Memorial Hall in its early years after its construction in 1896. This building is known today as the home of the Jacob Sears Memorial Library. Its Gothic Revival design was somewhat unique to the area, but was met with enthusiasm. Jacob Sears (1823–1871) left funds in his will specifically to construct such a building for the residents of East Dennis to pursue "educational purposes," and land on Center Street was purchased from resident Barnabus Sears upon which the hall was built, with a construction cost of less than $4,500.

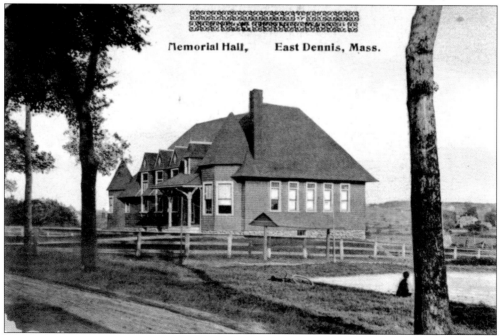

Memorial Hall, East Dennis, Mass.

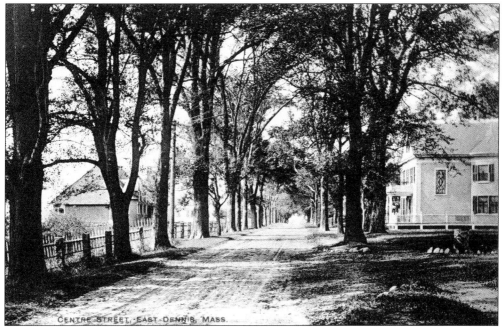

Here is a tree-lined view facing west near the driveway at 42 Center Street, which was the home of Capt. Christopher Hall, so successful a master mariner that he was able to retire comfortably before age 40. His neighbor and brother-in-law, Prince S. Crowell, lived next door at the home pictured on the right. Both played important roles as ship owners and in financing of the Shiverick Shipyard.

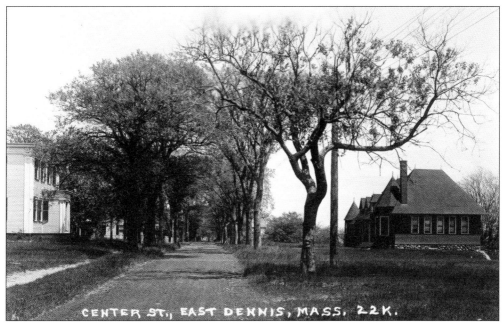

An eastward facing photograph near the opposite end of Center Street is seen here, with Jacob Sears Memorial Library on the right-hand side of the street.

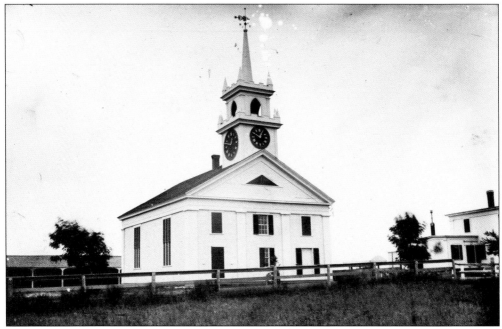

The original East Dennis Methodist Church pictured here was built about 1845. It was demolished in 1958 and replaced by the present church that currently sits at the same Center Street location in the Quivet village. This early-1900s postcard shows a carriage house in view (on left) for parishioners to park their horse and buggies.

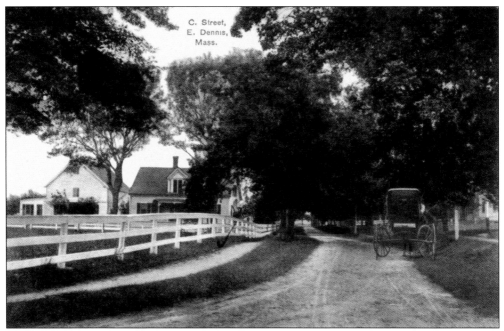

Seen here is a view looking north on Sea Street in the Quivet village. Along the immediate left of the street once stood an apple orchard on the corner of Center Street. Note that the out-of-town photographer incorrectly wrote the street name as C. Street. The 1835 home of Capt. Daniel Hedge can be seen up ahead on the left, where it sits today.

SCENE ON PLEASANT STREET, EAST DENNIS, MASS, 5.

On the point of land between Pleasant Street, North Street, and Cold Storage Road was the tinsmith shop (on the left), where utensils, tools, and all things tin were made for the villagers. The building no longer exists. The home on the right, built around 1819 as a Cape half house, had several wings, ells, and dormers added to suit the needs of those that have occupied it since.

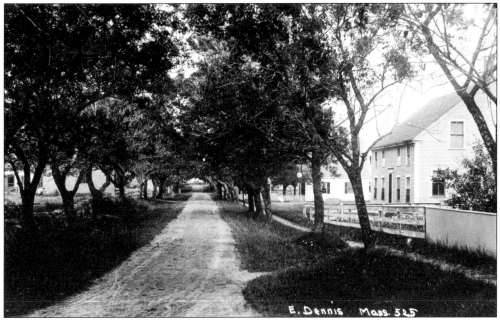

E. Dennis Mass. 525

A view from the east end of Pleasant Street, looking west, is seen here. The nearest house on the right at 10 Pleasant Street was built in Brewster and was a meetinghouse there through the mid-1800s. After being moved to this location, it became a straw manufacturing facility. Later it operated as an inn for tourism visitors. Once know as Old Red Top, a red colored roof still adorns the building.

To commemorate the extensive ship-building enterprise, which reached world prominence here during the mid-19th century, this monument was erected in 1924 overlooking Sesuit Harbor and the Quivet village beyond. Maritime activities became a major part of the economy after the War of 1812, and the Shiverick Shipyard at Sesuit Harbor led the way by building some of the fastest, sleekest craft known in that era—the clipper ships.

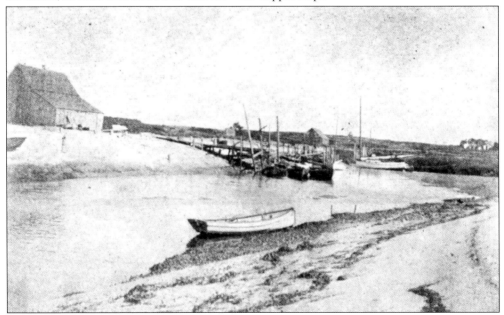

Brothers David, Asa, and Paul Shiverick were the proprietors of the Shiverick Shipyard, located on the west bank of the Sesuit Harbor. It is said that East Dennis was put on the map as a shipbuilding force through the presence and efforts of Christopher Hall, who influenced the Shivericks and arranged financing for the enterprise. Here is an old postcard showing the harbor channel in early 1900s.

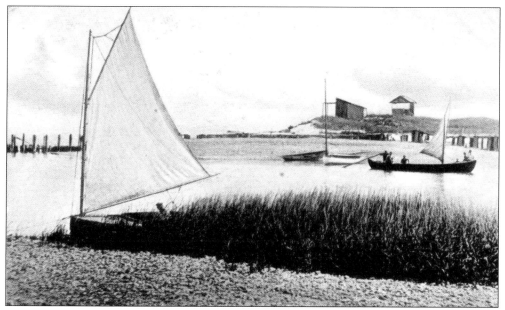

Eight clipper ships, which were each nearly 200 feet in length, and several smaller ships were built at Sesuit Harbor between 1850 and 1862. Quivet village was then bustling with activity related to the shipyard. By the time this postcard was produced in the early 1900s, that industry had ceased here and the harbor entered a much quieter period.

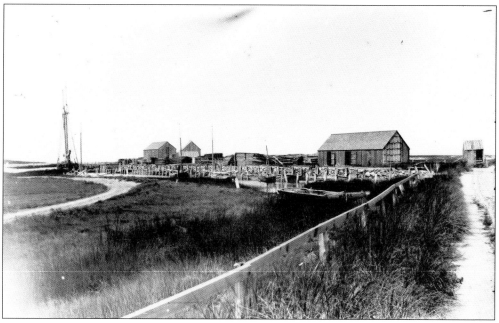

A variety of enterprises operated from the eastern banks of Sesuit Harbor over the years. The early-1900s postcard displayed here shows an establishment along the east side of the harbor, adjacent to what is now Cold Storage Road.

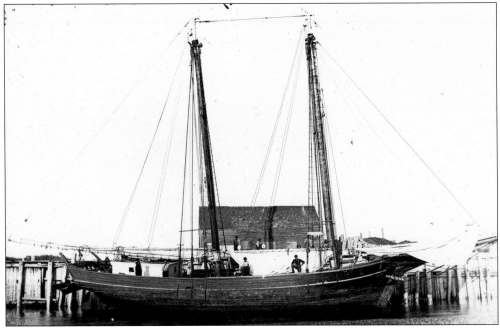

Here is a vintage image from the late 1890s at Sesuit Harbor with a coal ship at dock in the channel.

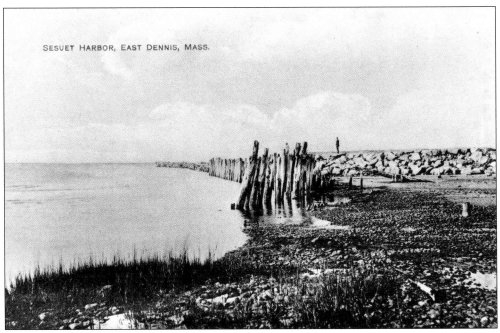

A long wharf once existed along the east side of the harbor before jetties were constructed. Perhaps this 1920s postcard shows the remnants of such a wharf or the remains of some other seafaring enterprise that was once located here.

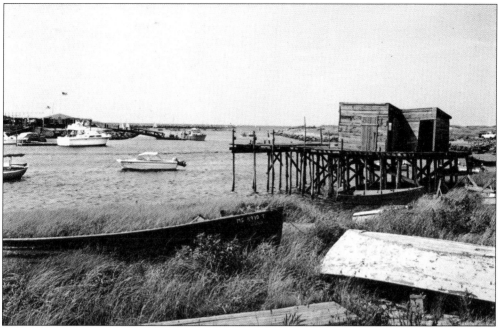

In the early 1950s the town decided to focus its efforts exclusively on maintaining Sesuit Harbor, rather than on both Sesuit and Nobscusset Harbor at Corporation Beach as they had done previously. At that point the Nobscusset location was no longer maintained as a formal harbor. The majority of Sesuit activity today revolves around pleasure craft, with commercial activity in the minority.

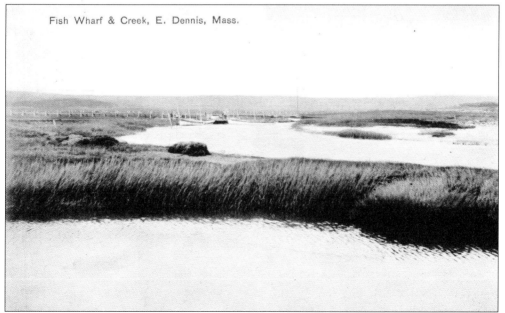

Fish Wharf & Creek, E. Dennis, Mass.

During the time that shipbuilding and the shipping trades were common in East Dennis at Sesuit Harbor, most of the workmen crossed the marsh and meadows over a footbridge like this one that connected from Sesuit Neck to the Quivet Neck side. This provided an easy alternative to traveling all the way around the creek in order to reach their homes in the Quivet village.

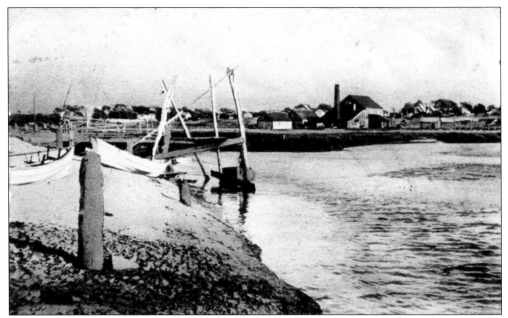

This early-1900s view of Sesuit Harbor was taken from the west side. Across the channel is a fish processing plant that once sat along the eastern shore. Fishermen would unload their catch here, and the processed fish would be kept in cold storage prior to being distributed elsewhere, thus the name for the street that runs past the location where this facility once stood—Cold Storage Road.

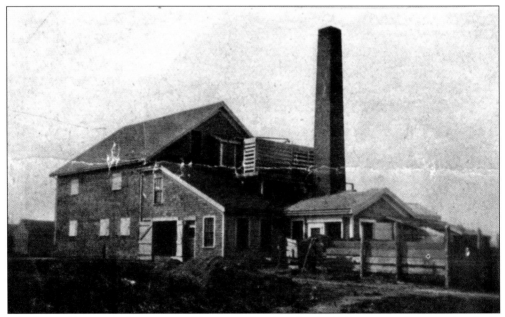

The first cold storage plant, pictured here, was lost in a fire in 1910. It was subsequently rebuilt on the same location with much larger dimensions and built with materials primarily consisting of cement block and brick, and it appeared more like a factory.

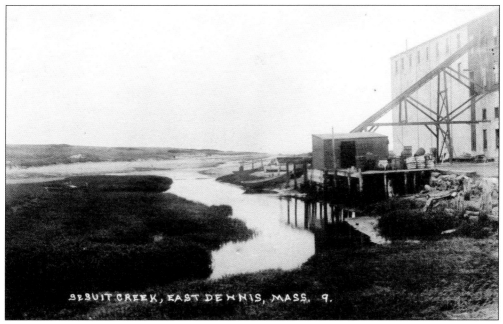

SESUIT CREEK, EAST DENNIS, MASS. 9.

As the 1920s progressed, the fishing fleets that worked Cape Cod Bay started taking their catch to Boston, as they were able to receive a better price there, and the fish processing business gradually ended in East Dennis before 1930. The processing plant was taken down at about this time, when the town then acquired the property.

Here is an old 1907 postcard view (possibly taken from atop the cold storage plant) looking up the hill from the harbor along Cold Storage Road. Several of the homes within the Quivet village are visible at the top of the hill.

Capt. John Sears of East Dennis was the inventor of a process to produce salt from sea water by way of solar evaporation. Many marsh areas in town, like this East Dennis one, had salt works in operation for this purpose. Salt was a necessary commodity for the locals in order to properly preserve their fish, and "Sleepy John's" invention allowed a once expensive product to be had in great quantity through the 1800s.

This 1906 view of the Quivet village was taken from somewhere upon the ridge running along the south side of Route 6A in East Dennis.

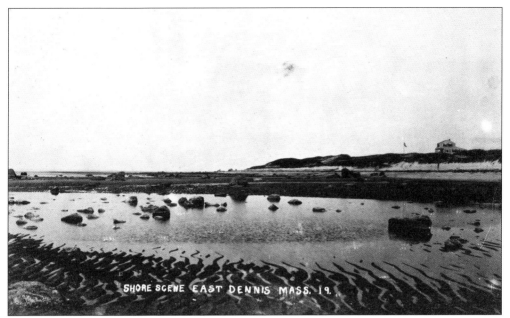

Here is an early view facing east from the sandbar at Sea Street Beach in East Dennis. The lone house that appears here is still standing, yet is now surrounded by several others. Except by an act of nature, there is reasonable assurance that the beach itself will continue to appear as it does in this picture. The Crowes Pasture Conservation land on Quivet Neck is just around the bend.

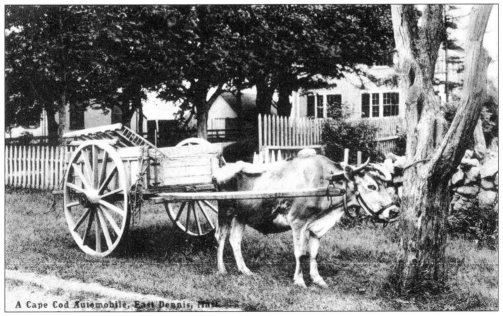

The first automobile owned by an individual within the town of Dennis belonged to an East Dennis man. This vintage postcard, produced at that time in the early 1900s, may have been poking fun at the newfangled tin lizzies, which then began to appear on the Dennis roadways.

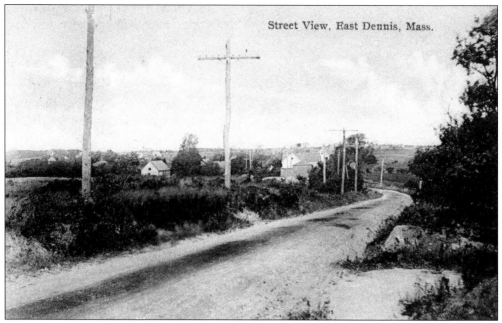

Street View, East Dennis, Mass.

There does not seem to have been many postcards produced that depict vistas of the Sesuit Neck area on the west side of Sesuit Harbor. However, this one from the 1920s includes the home of Stephen Phillips on the left (north) side of the street, which for many years was the only home to be found upon this stretch that now bears his name. The house has long since been removed.

Actress Gertrude Lawrence built this summer home on Old Town Lane in the 1940s shortly after her marriage to director Richard Aldrich. From this vantage point it is likely that she could then see clear to the Sesuit marsh and creek, as well as to Main Street beyond. This was the first house that she had ever owned.

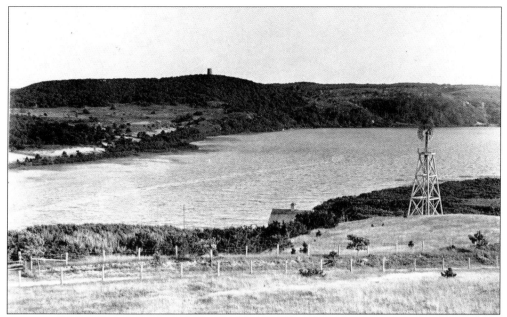

This photograph, taken from Newcomb's Hill, continues from where those on page 30 left off, with the photographer now facing south. Windmills like these have appeared many times throughout the images portrayed in this collection. Their function, for those residents who could afford to erect one, was to pump water from the owner's well. Those unable to afford this convenience relied on manual hand pumps at their properties.

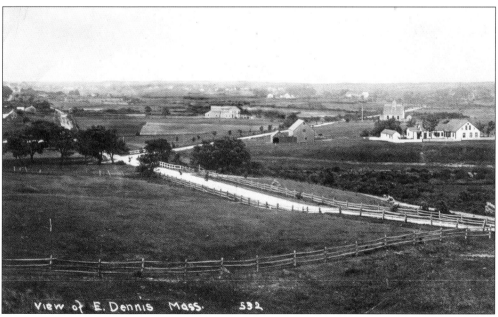

View of E. Dennis Mass. 532

The photographer has turned again to the left, now facing east and showing Route 6A running downhill and then curving off toward the top right. The Paddock family homestead is visible in the far right foreground. The North Dennis High School is the next building on the right along Route 6A (with cupola) and is now the house located at the Cape Cod Paper Company property.

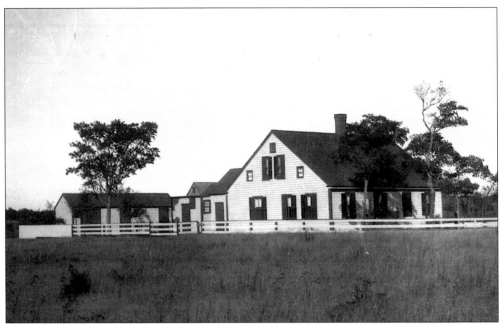

Sections of the Paddock family house pictured here date to before 1800. This early East Dennis settler family also lived within other structures on their land that stretched along Main Street from Scargo Lake to Scargo Hill Road, dating back to about 1660. In 1920, the last Paddock family member then living here sold this home to the one family that has owned it continuously since then.

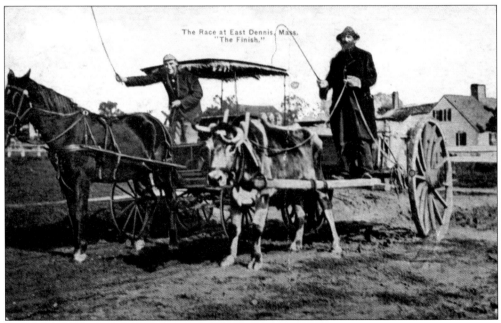

Farming the land was as common an occupation for many Cape Codders as was fishing. These two "old salts" appear to be horsing around with the photographer, or vice versa, since everybody knows that no ox could ever beat a horse in any kind of race, in this old 1910 postcard titled *The Race at East Dennis, The Finish*.

BIBLIOGRAPHY

Deyo, Simeon L. *History of Barnstable County, Massachusetts*. New York: H. W. Blake and Company, 1890.

O'Connell, James C. *Becoming Cape Cod: Creating a Seaside Resort*. Hanover, NH: University of New Hampshire Press, University Press of New England, 2003.

O'Neil, Neva. *Master Mariners of Dennis*. Dennis, MA: Dennis Historical Society, 1965.

Reid, Nancy Thacher. *Dennis, Cape Cod: From Firstcomers to Newcomers 1639–1993*. Dennis, MA: Dennis Historical Society, 1996.

Rogers, G. Kenneth. *A History of the Congregational Church of South Dennis*. South Dennis, MA: 1992.

Walker, Patricia. *Nobscusset Harbor at Corporation Beach*. East Dennis, MA: Harvest Home Books, 2005.

Perry, Ernestine, ed. *The White Spire*. West Dennis, MA: West Dennis Community Church, 1967.

Across America, People are Discovering Something Wonderful. *Their Heritage.*

Arcadia Publishing is the leading local history publisher in the United States. With more than 3,000 titles in print and hundreds of new titles released every year, Arcadia has extensive specialized experience chronicling the history of communities and celebrating America's hidden stories, bringing to life the people, places, and events from the past. To discover the history of other communities across the nation, please visit:

www.arcadiapublishing.com

Customized search tools allow you to find regional history books about the town where you grew up, the cities where your friends and family live, the town where your parents met, or even that retirement spot you've been dreaming about.